LA FRANCE DE PROFIL

PHOTOGRAPHS BY PAUL STRAND

COMMENTARY BY CLAUDE ROY

LA FRANCE *DE PROFIL*

APERTURE

THE JOB OF BEING FRENCH

For almost all Frenchmen, being French is the only vocation they cannot actually choose: it is in the air that penetrates the lungs of the newborn baby—barely having left its warm cave—and that rushes out again in his first heartfelt cry, a cry very much like real sorrow. In that first moment, the job has already begun. It's too late to change your mind, to begin everything over again. There you are—without having asked for it—you have been pledged to red wine rather than to tea, sake, beer, or manioc alcohol; you are now dedicated to the Reims Virgins rather than to the icons of Benin or to the Statue of Liberty; to the card game of *manille* rather than gin rummy, mahjong, or morra. There you are, just ten pounds of flesh, and already along your path lies a horizon of modest hills, of Little Red Riding Hoods, of Gaulish ancestors, of pawns named Petit-Chose, sergeants named Ronchonnot, of cafés with names taken from working trades and from the Greco-Roman tradition. It is too late to be born with epicanthic folds, a bronze tint to your skin, a pareu or a grass skirt around the hips; too late for the word *papa* to be spelled papa, too late for Sunday's entertainment to be called cricket, baseball, or hula-hula—it will be soccer, just as it is for everyone else around you. You might well choose to be a carpenter or an actuary, a married man or a bachelor, a radical and radical-socialist or a communist; you might well prefer your Picon with or without grenadine. But you no longer have any choice in the words with which to express it, nor the air that will carry those words, nor the passport they will give you when you want to leave the country. A very small but different mixture of chromosomes and spermatozoa would have sufficed to make you an heir to Schiller, Beethoven, and Goethe, to make you the successor of Don Quixote and Sancho Panza, or to give you seventy thousand characters of Chinese lettering to learn rather than twenty-six letters of the Roman alphabet. Well then, have no regrets. There's still plenty to keep one life occupied, several in fact, with the job that awaits you, the difficult and trying, the charming and nasty job of being French.

You will, I hope, get past that first and elementary patriotism that is merely a somewhat aggressive and not very clear affirmation of liberty versus necessity. You will not stop at the conjugation of the verb "I am French" as one stands by the verb conjugation of "I have red hair" or "I am six feet tall." Thin people need to sneer at the fat to justify themselves for not having been able to be anything but thin. Sad folks need to be scornful of the cheerful to give integrity to what their glands, their hormones and chance have given them, the character they have chosen to give themselves. What is arbitrary and accidental is what is most strongly, sometimes furiously, maintained. No, I don't need to claim that England is gray, dirty, drizzling with soot, rain, and fog; or that the Germans are heavy, stuffed with the makings of *choucroute*—sour cabbage and sausages—and beer; no, I don't need to tell myself all sorts of ills of the Italians, the wretched Russians, the morose Belgians, and the bored Yankees in order to make being French into a pleasure rather than a twist of fate. I don't need to tell myself every morning that, if I had it to do over again, I would still choose to be born between the blue line of the Vosges Mountains and the green fringe of the Atlantic Ocean. France is a random site

from which I create my own way of escaping at random. "*To the extent that the mind understands all things as being necessary,*" Spinoza said, "*it has a greater power over feelings; in other words, it suffers less as a result.*"

My country offers me the choice of every color imaginable, not just the imperative blue, white, and red. It is, by turns, a dog's life, the draft of an ill wind, and a need to take the bull by the horns—and then, too, it is living life in clover, a gaulish cockerel rolled up in dough, as good as good bread, as good as good dough. I have my work cut out for me with all the rats I smell, the inside stories I don't know, it makes my head spin and I can't make head or tail of it. The people of my country rock me in a cradle of illusions, but I can always be sure that they'll provide me with shoes that fit. It's enough to put one's back solidly into that harness of misery, it's enough to go the way of schoolchildren, who make no bones about it since their only way is to play hooky. By holding a candle in the sun, putting the cart before the horse, in two shakes of a lamb's tail, I am at the beck and call of the advice that the four cardinal points give me. It drives me nuts until the voice of a little girl, who's picking blackberries from a bush, rises up and, at last, translates into French what the lark said in bird language:

Saturday will wed in trust
Mister Sunday under a bower
My bread it has no crust
Where is the periwinkle flower?

It is with these forty-two million people of all sorts that I must manage to get along. It is with them I have to deal, them I will love, hate, detest, embrace, them I will run up against, rub up against; I will refine myself with them, and exhaust myself with them. The procession of headquarters and departmental subdivisions approaches my cradle, bearing gifts chosen for me by other people. These rivers flow toward me, descending from their spring. It is only in fairytales that fairies come to bow over the newborn. My fairies are this civil status of deeds—kind deeds and misdeeds—that defines me even before I have encountered myself. This is what I must opt for: the profession of being French has a tremendous hold over me.

Perhaps you must despise France in order, one fine day, to learn to love her again, really love her. This stubborn and persistent obstinacy about becoming French, which for centuries millions of dead (and their shepherds) have perpetuated—about designing this hexagon that was their preserve, about making themselves a country as one would dig a hole for oneself—you may deny and disclaim it. But most assuredly you will have to reinvent France, and after having wanted the explosion of this love that is all too blind, you will simply have to broaden it and allow it its purpose. Thus, the profession of being French, if you do it right, does not merely concern your own people and yourself, but people everywhere. It is not just a question of being French oneself—it is a matter of concern to all people.

It is a matter that will bring you more pride than vanity and more distress than pleasure. I started to love my country truly the day that I stopped priding myself on her and learned to blush

about her at times. I understood what it meant to be a *French citizen* when I managed to meet the gaze of those who not only saw me as connected with Joan of Arc, Molière, Pasteur, Jaurès, and the cyclist Louison Bobet—but before whom I suddenly felt responsible for the fall of Madrid, the bombing of Hanoi, the burning of an unknown village in North Africa, and the execution of a Malagasy man whose name is more difficult to pronounce than his chest was to be shot full of holes. Being French takes on its full meaning when one is not just the compatriot of her great figures and her masterpieces, but also the accomplice of her villains, the representative of her best and her worst, the permanent ambassador of national honor and dishonor. There is no love that is pure bliss.

You can catch the French nationality the way you catch a disease, sunstroke, or the way you take in the air you take in. The profession of being French—that has to be learned. No, I won't say that it is the most beautiful profession in the world. There is no such thing as the most beautiful profession in the world. There are those that are more or less difficult. The profession of being French is fraught with thorns. One is never done with being an apprentice.

If it were simply our lot to learn ways of getting along and to have recipes for understanding that those who preceded us invented, ah, how easy all of it would be! But history does not come to us so easily, like some carefully set table, on which our silverware awaits us, the menu written in advance, the chair extending its comfort. We arrive unexpectedly, tousled and unkempt, into a squabble that hasn't begun to come to an end yet, smack in the middle of an argument, a quarrel, a long and resonant secular griping. We are thrown headfirst into a family brawl where we are coerced to take sides before we even know what game is being played. The less needy spirits come through with an elegant kissing all around and give the fine and reassuring name *French dialogue* to this age-old exchange of insults and blows. Proverbs come all prepared to reassure the insecure. Come, come, it takes all kinds to make the world go round; there are good people everywhere; all are wrong in their denials, right in their confirmations; bad battles make good friends. Trouble is, none of this is particularly true. By sitting on the fence, you receive more blows than enlightenment, you reap more bruises than wisdom. The game must be played. Here we are, grabbed by the scruff of our neck and, without having yet had our say, we are thrust into the general scuffle that began long before we were there.

The biped whose name is Frenchman vacillates between using the conjunction *but* and the conjunction *and*. This is France, but the France of the Rights of Man, of '89, of '48, of the Phrygian cap of liberty, the helmet . . . France, the France of Joan of Arc and Gabriel Péri, Saint-Louis and Saint-Just. However, we have to go beyond the word *but*, beyond the word *and*.

And it is not a question of opening one's heart so wide that an eternal Bastille could be erected there, in which some defend the crenellations while those below are taking them. But I love the words of that old, gruff, hardheaded French worker, whose name is like foam and sunshine, like old stones with the patina of great age and ivy and time, the words of Gaston Monmousseau, Tourangeau. He speaks of the châteaux on the Loire built by princes and noblemen who made peasants, craftsmen, stonecutters, masons, and roofers work their fingers to the bone. And after four or five centuries, he's still fed

up with these nobles who had palaces built by the sweat of the brow of others. Nevertheless, he is pleased and proud and warmed to the heart when he looks at those towers covered with slate, at the sun setting in the thousands of panes, at the sculpted paneling, and the double-winding staircases. Then that old descendant of those who built so that others might dwell murmurs, halfheartedly: "*There's some of me in there.*"

Learning the profession of being French is just that. It is discovering what there is *of us*, what there is that is ours in what at first seems to belong to other French people, in what (at first) makes itself out to be *against* us. They put into our arms this skein, tangled with legacy and with treasures, this ball of yarn, a mix of injustices and gifts, this shrub thorny with abominations and marvels. It's up to us to decipher what is there of ours in what is not us. I hope you'll have fun. I promise you'll have some worries. I predict that you'll get something out of it. The tour of France on which we are companions, you and I, will play many a trick on us.

You thought that being French was just a way of being, that you could bathe in it without paying attention, as you bathe in air and that mindset that is circumscribed by mere language. You thought that being French was something that happened of its own accord. *Mais non.* Being French is a way of becoming. It is unending. Nobody can say: "I have nothing to do with it." Nobody can make you answer: "I didn't ask anyone for this." Nobody asks your opinion, for you to feel compelled to give it. "I am France," the rooster says. "Not so, I am France," says the lark. You will have to decide for yourself in this perpetual duel between the lark and the rooster, Roland and Olivier, Racine and Corneille, the *sans-culottes* and those who do wear one, the humble cottage and the castle. What makes it complicated is that, on either side, you will clearly feel that there is "*some of me in there.*"

The only inherited enemies worthy of that name are those our country itself suggests to us. Yet, it is too easy to hate someone one doesn't know, to despise a shadow, a caricature, a foreign shape. There is more merit and more meat in despising someone whom you can understand so well because there is some of you in him, because there is some of him in you. Civilization is not made by jabbing and thrusting at the specters from abroad, it is made from the blows of civil wars among those who are living here. Disagreements are profoundly transformed only by putting everything in the same mode, that is to say in the same terms. It happens only with those who understand you that you can't get by even with full knowledge of the facts. All the rest is misinterpretation. Misinterpretations are not instructive.

A child believes that a homeland is where he lives. Wrong. The man discovers, as he becomes a man, that a homeland is what inhabits him. I have met Frenchmen at the other end of the world who believed they had lost the habit of being French, who were no longer feeding themselves on steak-frites, ripe cheeses, and baguettes. But Danton exaggerates: the homeland is carried along on the soles of one's shoes, because it has meshed and lined itself with you. Along with the problems of faucets and trains, as soon as we know how to stammer a few words, another problem is given to us to solve, the problem of being what we are. Will anyone ever be certain to receive the diploma in the art of being French?

It is easy to see what is expected of the French abroad: they should be those who discourage dancing around the throne, the altar, and confident husbands; they should come into cities and lives as Captain Robert enters Milan at the beginning of the *Charterhouse of Parma*. The French are expected to have a disorderly way of imposing an intelligent order; expected to be the oldest sons—annoying and insufferable—of the Church and of the Revolution, the French Revolution that need not be called French because, after all, it began in Paris. What is expected of the French is the unexpected, that fantastical aspect of history called insurrection, and that romance of private life called adultery. They are supposed to be lighthearted and brave, incoherent and wise, greatly resembling the truth of Epinal's images, legendary types, picture postcards, fables, complete with recipes of fine cuisine, a fine language, winning mustaches, and strong minds. The French are expected to shake everything up—including the idea one had of them.

But what is harder to know is what the French expect from themselves.

The difficulty in being French lies in the embarrassment of choices, in the muddle of these contradictory positions that confront the bread-eater born between the North Sea and the Mediterranean, one leg in a silk stocking, the other in a woolen one, halfway between the enfant terrible who is having fun and the man who fights, between Cyrano and Pascal, between his grandfather Jansenius and his uncle Voltaire.

Abroad, in countries that are less complicated, less inextricable, a great man may be the one who cuts Gordian knots in two, the man who has passed over history's difficulties without a touch of the sword. But it is no accident that has made us choose as national heroes those great men who are both prodigiously greedy and marvelously generous, who give us the sense that they have disentangled rather than cut, chosen rather than forsworn, agreed to rather than toppled, all that disturbed them. Our national poet is not the most straightforward person; he has several faces. He is that sheaf of constancy and that bundle of contradictions, he is the one who has most cleverly sorted out his blue blood from his white blood, a son of the Vendée and of the republican, père Hugo. We love him and revere him for being both a sum of things and a man, for having known how to demonstrate that the difficulty of this profession of being French may be resolved in the same way that movement is demonstrated: by walking. French heroism does not consist of making one's way through the bush or the enemy. It consists of making one's way through France. It is not a question of carving wildly into a foreign substance. It's about cutting into one's own living flesh, into the "*there is some of me in there*" of others.

Our national poets are not "poet laureates": they preferred the crown of thorns to the crown of laurels. They're not comfortably seated in the easy chair of the father and peer of the homeland, they have not braided their praises and sown their benedictions with the calm of those who fly into the storm like seagulls, but, rather, of those who drift as do small boats Look at Monsieur Pierre Corneille, Monsieur Victor Hugo, and Monsieur Louis Aragon. How they entertained, how they hurdled, how they suffered! They're saturated rather than dried up. They're Olympic rather than Olympian. They're soaked in sweat rather than sitting in seventh heaven. They've come a long way.

You learn by your mistakes. Everyone recognizes himself in them, because everyone has had to go the same path.

The history of France is not a garden one can slip into without being scratched by the brambles and getting drenched by the rain. The history of France does not resemble a French garden. There is only one honorable form of pride by which the French can warm themselves: the knowledge that the profession of being French is not a fun game. . . .

I remembered this when I began to look at the hundreds of photographs Paul Strand put on my table. He had just finished his journey accompanying the Tour de France (the other fellows surely must have called him the Wise One From New England).

It was in New York that I had the first shock Paul Strand was to give me. It had been a good thirty years that Strand was already famous in the city, where, in 1890, he was born on the West Side. He had been involved in the whole tumultuous and passionate emergence of works and ideas that began to crystallize around Alfred Stieglitz and his small gallery "291"—so named because its address was 291 Fifth Avenue—from 1907 on to his death. Stieglitz was a very great photographer and a rather peculiar spirit (with a very curious mind as well). He was the first to introduce Americans to Cézanne and Picasso, to Douanier Rousseau and Matisse. And (even better) he introduced Americans to some Americans of rather great stature: John Marin, the man who is perhaps the only, in any case the greatest American painter, and I wonder why he is so little and so badly known in France. And there is Paul Strand, the man who is without a doubt one of America's greatest photographers.

In 1945, at the Museum of Modern Art in New York, the sum and substance of Paul Strand's photographic work between 1915 and 1945 was presented in a great retrospective exhibition. That is where I found myself confronted for the first time with these silent and grave images, whose beauty goes against the grain of all the easy ways in which photographers ordinarily like to indulge and provide for our eyes. At the same time, in the projection room of the Museum of Modern Art, they were showing Strand's films, from the poem-documentary on New York, shot in 1921, entitled *Manhattana*, to the film *The Wave* shot in Mexico between 1933–1935, to the epic of 1942 called *Native Land*. In these films one saw the whole essence of what is Strand, his way of focusing on faces and things with a look that is not merely a glance, that does not seek to grasp the fleeting movement or to express metaphorical relationships, but works in a scrutinizing way, copiously questioning, with a deeply moving patience and ingenuity. In this important retrospective there were samples of all of Strand's endeavors and all of his research, a testimony to the hundred and one ways in which he had sought to have the glazed-frosted-polished camera's eye speak of *something other* than what it had been made to say until then. His curiosity for machines aligns his production of the twenties with Fernand Léger's painting, his *abstract* experimentation, that gave him total mastery over his instrument, all that passion that made him participate so intensely in the ferment, the comings and goings—in the workings rather than in the backward turns—of his era. But what came to my eye and heart most violently and most peaceably was that burgeoning inscribed in the photographs Strand brought back from his

lengthy stay in Mexico, around 1933, followed ten years later by his painstaking retreat into New England, that austere cradle of America. It was during the same period that he had created the restrained and difficult film, *Native Land*, which is perhaps his masterpiece. It is much more a testimony than a satirical tract. An essay, which might have as its title "Essay on injustice, racism, and murder, considered as fine arts in the contemporary United States."

And, in the photographs of Mexico and New England (despite everything that separates the immobility of the print from the movement of the motion picture), I found the same anguish and the same emotion. Strand made a contained sensitivity emerge from the reactive plate; the ostensible coldness of his images made the muted warmth of what he had to express even more astonishing. He would

place himself in front of a man's face, in front of a tormented Christ of an old Mexican church, in front of a New England farmer, in front of a door of wormy wood, of an agricultural tool completely polished by human hands and encrusted with soil, and he would *let it happen*. Without cheating. Without accentuating. Without playing the thousand games of artifice and of so-called art photography. The result was disconcerting, unrelenting, unforgettable.

MARC
SAINT-SAENS

Five years later, I saw Strand come to Paris. With his farmer's gait, his fine, smoke-dried, leathery face, his patient hands, his odd resemblance with a certain face of Picasso's (Picasso without the feverish emotion) and a certain face of Rouault's. With that gentleness that sometimes seems languid but is merely contemplative, with that slowness of a long trek that so often made us seem to disagree when we were working together, when in fact we enjoyed the realities of the complicity that opposed and complemented us, that irked and enriched us. And Strand stuffed his car, the nomadic vehicle of human reality, full of his gear consisting of large and heavy cameras, his equipment that looked more like the apparatus of a photographer of the era of Nadar, Bayard, or Atget than the lightweight and changeable instruments of the young poet-reporters of the Brassaï school, the fine team of the Cartier-Bressons, the Doisneaus, the Izises, and so on. Strand took to the road. A sluggard's road, capricious, unhurried, a musing road of daydreamers, a road that resembles the path schoolchildren take more than the direct flight of birds. A road without a system, with no goal other than to trap a maximum of humanity, the most humble and *naked truth*. A road that, with mocking disregard, avoided

just about everything the "foreign" photographer who decides to produce a series of photographs—a book—on France frequently feels obliged to see close up. For Paul Strand did not photograph Notre-Dame or the Château de Versailles, he did not photograph Chartres or Mont-Saint-Michel, neither did he photograph the Pernod bottle nor the black hat of the ladies with green hats, nor the mustache and beret of the passing gentleman, nor anything that might at first glance appear to be unique, typical, or special to someone who has come from the other end of the world to discover France. What characterizes Paul Strand is that he never limits himself to or lingers on the *first glance* in any place or at anything. What characterizes Paul Strand is that this "foreigner" did not stop at what usually seems strange to strangers or to the French themselves. He has taught us something about our country, her people, her "life-styles" without any styles and sometimes almost without any life, so much does life here crawl along, parsimonious and dulled, not because its look has an exceptional glow, novelty, and candor. Paul Strand did not enter French life as someone coming in *from the outside*. His itinerant photographer's harvest is disconcerting only to the extent that it unnerves us because it places us right at the heart of what we no longer see, and makes us see it. Strand did not look to artificially *re-create* his subject, France, with cunning or ingenuity. He simply sought to penetrate it. He allowed himself to descend into the reticent depth of the nation France, with the submissiveness of a stone that drops to the bottom of a well and makes all kinds of ordinary discoveries on its way as a falling stone.

What he had to tell us upon his return, this companion of the Tour de France, the Wise One From New England—well, it wasn't so joyful, nor so flattering, nor so delightful. But I do believe it was very beautiful. You'll see.

Because, for nine-tenths of those who practice it, the profession of being French is a rather exhausting job. I gleaned some advice that must be very good advice from a treatise on beauty intended for the use of ladies who want to stay young. To stay beautiful, to stay young, you should sleep ten hours a night, preferably have breakfast in bed (a cup of tea, a glass of orange juice). You should practice some (relaxing) sport such as golf or yachting (your face coated with a rich cream), and above all you should avoid intense emotions that cause facial muscles to droop, worries that cause them to constrict, and woes that irritate the tear ducts and the nerves. In the final analysis, it isn't so very, very difficult to stay beautiful, to stay young.

Charlatans know how to read the future in the lines of the hand. But it is a great deal easier and much more certain to read the past in those facial lines they call wrinkles, in the lines in stones they call erosion, corrosion, mould, in the lines in wood they call moss, patina, wear and tear. That is what Paul Strand does. He does not provide human beings and their environment with a flattering, satisfying, and benign reflection. He lets faces and walls tell a story that has no relationship whatsoever with the program laid out by writers of beauty and youth manuals for their clientele.

The huge and heavy square apparatus that Paul Strand likes in particular to use does not produce *snapshots*. He does not hold up a very graceful mirror to the elusive moment; he captures nothing

other than what a long time of patience and grief, of whirlwind and docility has managed to accumulate in the depths of one's being and, with little bits of help, to imprint on the outer covering of people, trees, and stone. He does not recount the accidents of chance, but the accidents of the hard work of living that leave their marks on features and on the world that mankind has made into its image. In one fell swoop, he recounts the life of the French, the profession of being French. Across all these frontal images, it is a portrait in profile that is drawn. Across all those motionless windows open to what is real, it is the movement of a people that is guessed, the tenacious and noble shuffling of men in motion. The black cloth that the photographer wraps around himself here becomes Véronique's laundry, miraculously inscribed with the everyday patience and passion of people without a history but not without stories. Of those people who are said not to have a history because they don't make a fuss about everything. But it is they who make history. . . .

Gentle and verdant France . . . France, mother of arts, arms, and laws. . . . Oh, I don't know. I don't know anymore. I cannot manage to forget all that is needed in sweat, filth, weight, tears, worries, all that is needed in what is gray, black, silent, and in blows suffered to (also) make this vigorous France, whose best people dance rather than walk, defy themselves and destiny, and give the world the perfect representation of grace and offhand manner as they perform. If I were about to forget this, here are these taciturn and obstinate images, here is the accuracy of the accurate reality. Here is the superb throng of the humble.

The humble? It is a manner of speaking, an ugly way of speaking that comes to the lips of those who bow down, who "go to" (to the people, the humble, the *others*). Rather, what stands out is those unknowns who will not have plucked, and not even glimpsed, the roses of life, the roses of life of those who can live in leisure; what stands out, rather, is a tenacious, indomitable, and silent pride. That is what makes this undoubtedly sad book into a radiant book, nevertheless. That is what makes this testimony, the discretion of which itself has a tragic note, into a song brimming with spirit and confidence. That is what is communicated to someone who lives for a moment within the intimacy of these gazes that hold no reproach but yield to no one, of these houses gnawed at by the leprosy of time, the oxide of the seasons, the lichen of quasi-wretchedness, of these landscapes so sublime and so ordinary, these gray and low-hanging skies, these inanimate objects whose soul is shimmering at last.

It is a difficult job, this job of being French. But after all is said and done, those who practice it do have some reasons to be proud of it. It is not a lofty, crowing pride, it is not a theatrical or rankled pride. It is a tacit pride, without any aggression, without any emphasis. I think you will know how to read it in these pages that I shall now let you open as one opens a family album. I leave you to these unknown relatives, whom the photographer's lens will reveal to you. You will recognize them. The floor is theirs, those who never have the floor. They have so much to say.

—Claude Roy

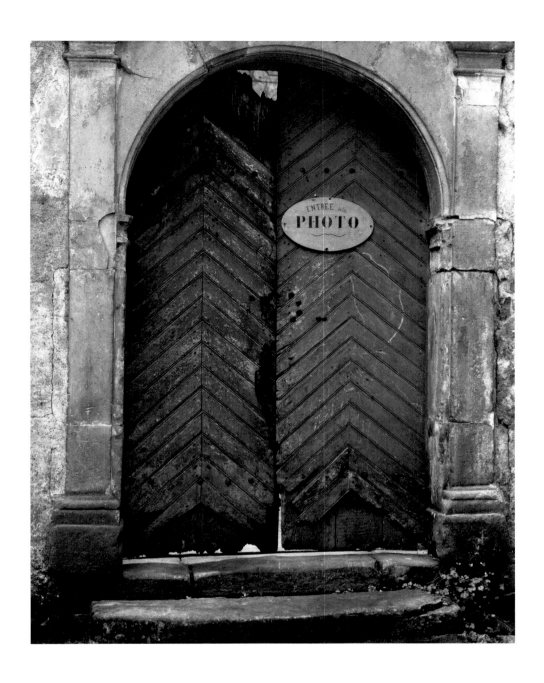

THE PHOTOGRAPH'S ENTRANCE . . .
ENTER INTO THE PHOTOGRAPH

Come in, please, and make yourself at home. After all, you are at home. People, mirrors, and photographs each have their own personal way of reflecting. The photographs here, even if people seem to be missing from them, do nothing but reflect people. It is only out of the most absolute politeness that people give this back to them. Reflect a bit upon these photos that reflect you, that wordlessly suggest to you an examination of trust. Enter into the photographs, immerse yourself in their silent dream and their speechless meditation, move, stop moving, smile, don't smile, it doesn't matter. But above all, do not let the little bird out. The photographer had quite a lot of trouble catching the bird of poetry by putting a grain of hyposulfite salt on its tail—which is called, both in the darkroom and in truth, a developer: a révélateur.

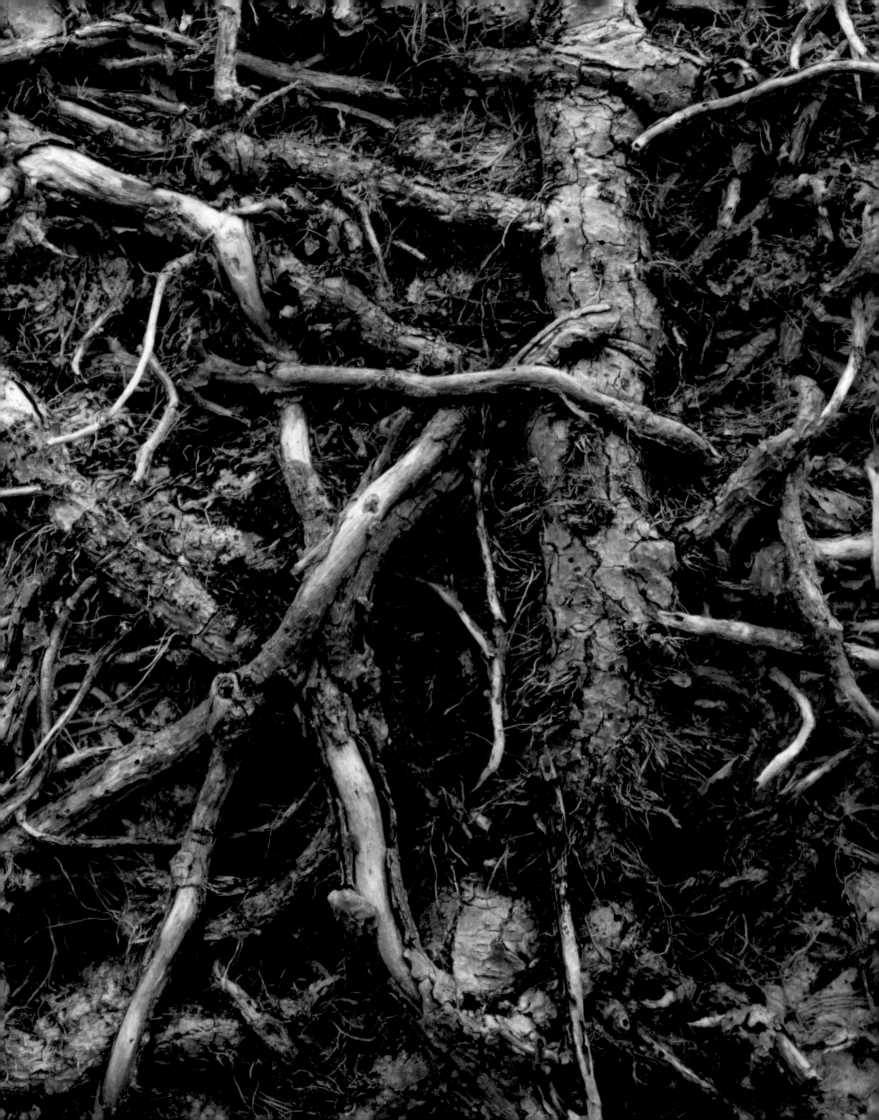

Quand la terre était la terre
Fauve odeur d'alluvions
un grand sommeil quaternaire
tout englué de limon

La terre ne savait pas
ce qu'on allait tirer d'elle
ni tout ce grand embarras
de vivants si tôt mortels

Pouvait-elle imaginer
des clochers avec un coq
des maisons à cheminées
et des routes dans le roc

Pouvait-elle supposer
le vin rouge le pain blanc
des jardins bien arrosés
tant de rues et leurs passants

La terre ne savait pas
qu'un jour ce serait la France
ces gens dans leur coin là-bas
leurs bizarres existences

La terre n'était que terre
racineuse songerie
où l'humus et le calcaire
complotaient d'être la vie

Histoire Géographie
n'étaient que des hypothèses
que suggéraient à la nuit
les ténèbres de la glaise

Il n'y avait sur la carte
pas de France dessinée
ni les coteaux modérés
ni la patrie de Descartes

Lourde aujourd'hui de passé
d'histoires de gens remuants
la terre est très dépassée
par tous ces événements

C. R.

Avant nous le déluge.

When the earth was earth
alluvia's musky scent
a great quaternary sleep
bogged down deep in silt

The earth did not yet know
what would be drawn from her
nor did she know the great profusion
of living beings so soon to be

Could she imagine
bell-towers with roosters
houses with chimneys
and roads in the rock

Could she guess
red wine white bread
well-watered gardens
so many streets and their passers by

The earth did not know that
this would one day be France

the people there in their nook
their mysterious lives

The earth was just earth
root-bound daydreaming
where humus and limestone
were plotting for life

History, Geography
were mere hypotheses
the darkness of the clay
suggested to the night

On the map no France
had yet been drawn
no modest hillsides
no homeland of Descartes

Today, heavy with the past
with stories of people stirring
the earth is overtaken by these events.

—C.R.

Thus

the general, the universal spirit of the land was formed. The local spirit disappeared with each passing day; the influence of the soil, the climate, the race, made way for social and political action. The destiny of place was vanquished, mankind escaped from the tyranny of material circumstances. The Frenchman of the North had a taste of the South and bathed in its sun; the Southerner took something of the tenacity, the seriousness, and the reflectiveness of the North. Society and liberty tamed nature, history erased geography. In this marvelous transformation, spirit triumphed over matter, the general over the specific, and the idea over reality. Individual man is materialistic: he happily clings to local and private interests; human society is spiritualistic, and seeks unceasingly to free itself from the wretchedness of local existence, to attain the high and abstract unity of the homeland.

The more one delves into ancient times, the more one removes oneself from this pure and noble generalization of the modern mind. The barbarian eras present almost nothing but the local, the specific, the material. Mankind still clings to the soil, is committed to it, seems to be part of it. Then history looks at the land, at the human race itself, so powerfully influenced by the land. Little by little, the very strength that is within mankind will detach him, uproot him from this land. He will leave it, fight it off, trample it; what he will need—instead of the village of his birth, his city, his province—is a large homeland, and thus he will place himself within the destiny of the world.

—Michelet, *Tableau de la France*

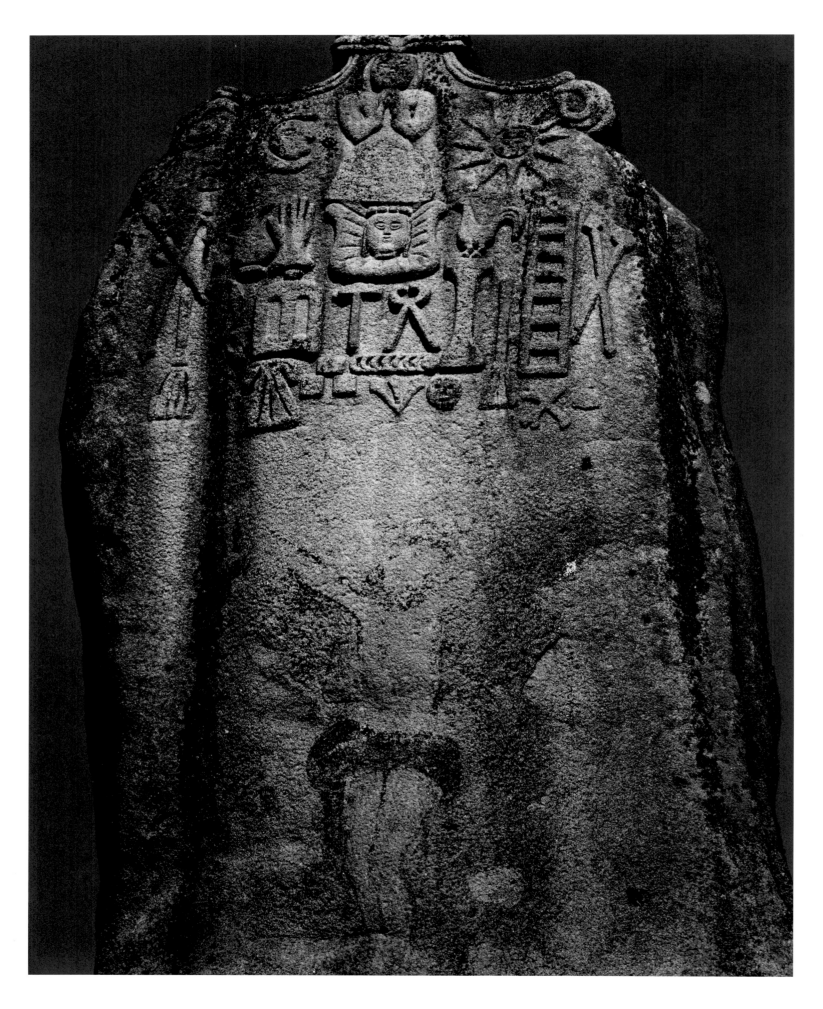

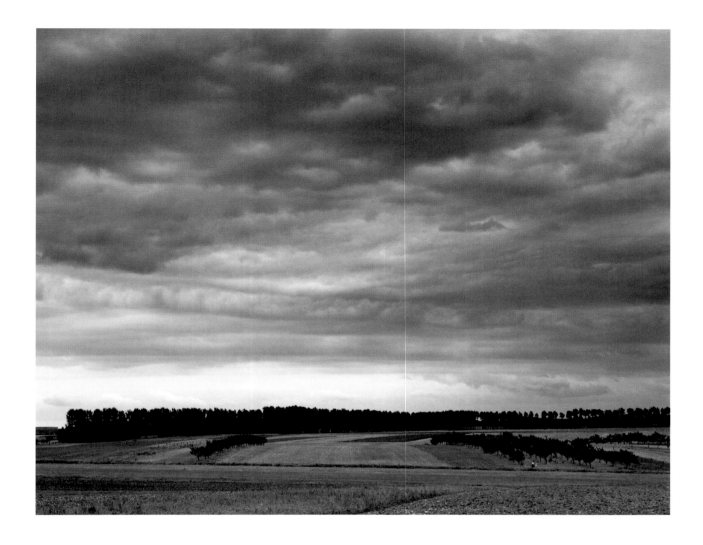

LA FRANCE DE PROFIL

A man who was not born a Frenchman but became one after having wandered through the world told me this, which I find quite beautiful: "Before, I had places to go. Now, I have somewhere to come home to."

That is just it, a country of one's own. One comes back to it as one comes back to one's home. I am French. I live in a house of language and history, of landscapes and customs. I live in a home. It does very well by me. The comfort of being French is that one didn't choose to be thus. The burden of being French is that one still must choose.

I do not want to be French in the manner of Gallifet (Gaston-Alexandre-Auguste, Vicomte de—1830–1909), the general from Versailles. He politely asked a column of Communards prisoners: "Let the foreigners raise their hands." He immediately had those shot. "Thus," he said, "we shall remain amongst ourselves." Let us not remain amongst ourselves; it is ugly.

The refreshing part of travel is the uncertainty, the surprise, all that shakes and overturns ideas and habits. The freshness of staying home is that one knows what to stand by, what to hold onto. Habits, even bad ones, are a relief, and conventions bring relaxation. Hence this purring patriotism that resembles sleep, that never consents to questioning anything: "*My country right or wrong.*" That is not virtue, that's laziness. Nevertheless, I can find an excuse for this, if not any justification. A homeland is (also) the sum total of those values upon which one need not reflect. Taking it to extremes, one's homeland resembles those clever clocks

that have a mechanical parade of little ceremonial figures that march at the designated time. But man is the animal who knows how to overturn mechanics so as to see what's inside. Before having the order of things as her essence, France embodies a certain disorder of the heart. Now, a heart has very little in common with a metronome. Passions have their own peculiar rhythms.

One dares to truly look at much beloved faces only in profile, maintaining the freedom to dream of them, to play at extricating oneself from them only to be compelled to connect with them in the end. I do not dare look my country in the face. My France in profile, I speak in a soft voice to the lost outline of your face.

France in profile is a June afternoon on a village square. In the distance one hears the clanging of the farmers stacking the hay. In its obstinate stone, the monument to the dead repeats by heart the alphabetical list of those who died in the two wars, from Abadie (Léon) to Vauthier (Charles). Right at the end there is the name of Martin (Jean) who had been forgotten, yet who died all the same and whose name was added, but for whom there had still been some hope when the list was put together and the plaque engraved. And through the open windows of the schoolhouse thirty voices are heard sweetly repeating *The-Loi-re-has-its-sour-ce-in-Mont-Ger-bier-de-Joncs.*

The Loire has its source in Mont-Gerbier-de-Joncs and France finds hers in Vercingétorix. . . . France in profile is the child dumbfounded by a history that could make you fall asleep on your feet: the history of France. Our ancestors the Gauls lived in a hexagon with a temperate climate bordered by seas and mountains, in huts garnished with mistletoe. The common folks lived in vile houses and the lords lived in lovely castles. So Henri IV said: "Rally behind my white plumes," and, since all the people had a chicken in their pot, they listened to him (except for Ravillac). The Parisians took the Bastille and the King took to his heels (for Louis XVI was nothing but a weak locksmith, but Robespierre was incorruptible). . . . France in profile goes straight to your heart when you are far away from France, all those little clouds of absurd memories that inevitably draw a portrait of good likeness: that way the French faucets will always have of letting their French water flow into the French problems of the French elementary school certificate, the smell of the nuts we crack at home in the evening, the smell of the vendor of French fries at 10 Boulevard de Clichy, the glazier's cry, the nightingale's song when he sings (in the original French) in my garden at night, the smell of the metro that suddenly rises from the street, the word *chèvrefeuille* (honeysuckle) and the words *pieds nickelés* ("nickel-plated feet," meaning to sit tight), the village named Mortefontaine, the street named Château-de-Rentiers, and whatever remains of home when, at the other end of the world, everything has evaporated.

France in profile is that illness called homesickness, because it is nourished by all the good a country did for you, that melancholy that lies like a slight mist over the specifics of your memories, that seasickness of the heart, a heart that wants to put its feet down on the ground—on very special ground. France in profile is being that Frenchman whom one looks right in the face, because with his way of laughing and gesturing he is the ambassador of austerity, the representative of Pascal and Saint-

Just; because with his way of being skimpy and so confused he is the delegate of liberty, the special envoy of the conquerors of the Bastille and of citizen Jaurés; because with his traveling salesman's suitcase or his order book he is the symbol of disinterestedness, the heir of the soldiers of the Year II; because, when all is said and done, and thanks to the wart on his right cheek, his straw hat, his alpaca jacket, and his pince-nez, he is the very image of a people with cheeks as smooth as the statues in Reims, hair in the wind like Joan of Arc, dressed in luminosity like Blériot, with eyes hard and new like Guynemer, and with the speech of a Giraudoux.

France in profile is the logic of contradictions, contradictions only for those who stand by the door but do not come in; that affection that Barrès has for Jaurès, and Aragon for Barrès; the pleasure Maurice Thorèz takes in reading Bénigne Bossuet, archbishop of Meaux, and the thoughtful tone in which General de Gaulle concludes in private that Maurice Thorèz is a Statesman; the way the French have of really liking one another within their animosities, the doffing of hats between the jabbings of knives, and that respect whose quality is measured precisely in the refusal to participate in rounds of public kissing.

France in profile is less a state of the soul than the soul of a State, less a melody than its harmonics. It is the weightless weight of imponderables, thus named because they make the heart feel heavy when they fly off, like birds whose function it is to unburden the trees by sitting on them, to make them forget the problem of their roots and the sad daily routine of immobility.

France in profile is not only what all French people love as a whole, a certain way the sky has of being sky and the sea of being sea and the grass of being green, then blond, then almost gray, then of being cut and becoming hay. A homeland is not only that which all the people of a country think they remember as a whole, a history. A homeland is not only the common places into which one enjoys being commonly transported, the proverbs of olden days, the ready-made phrases of the present day, ideas that are accepted and those that are not.

A homeland is not just all of that, it is not primarily all of that. A homeland is what the whole group hopes for. It is a way of imagining the future; it is the idea one has of what the next day should be.

And France does not stop in the hearts and minds of French people any more than clouds stop running across the sky, or the grass stops bending its stems when the wind blows, and the sea and the waves stop their endless trembling. It happens that you become desperate, it happens that you hurt in your country the way you hurt in your body. But that, too, is imagining; that too is moving forward. I love for my country to be all that it will be, even if I sometimes reach the sorrowful point of thinking that it is falling apart. A country is a promise.

So I lie down in the grass and watch the clouds in the enormous sky putting on their slow, silent show I listen to the wind run around like a slightly crazy hunting dog that sniffs the meadows and the waves in his own fashion, I listen to the lark sing in the right-hand corner of Paul Strand's photographs (but still I'm quite afraid that you won't see her, so small is she, dressed in fresh air and vibrant light). I listen to France breathe and I think of the future. A fine future, also in profile.

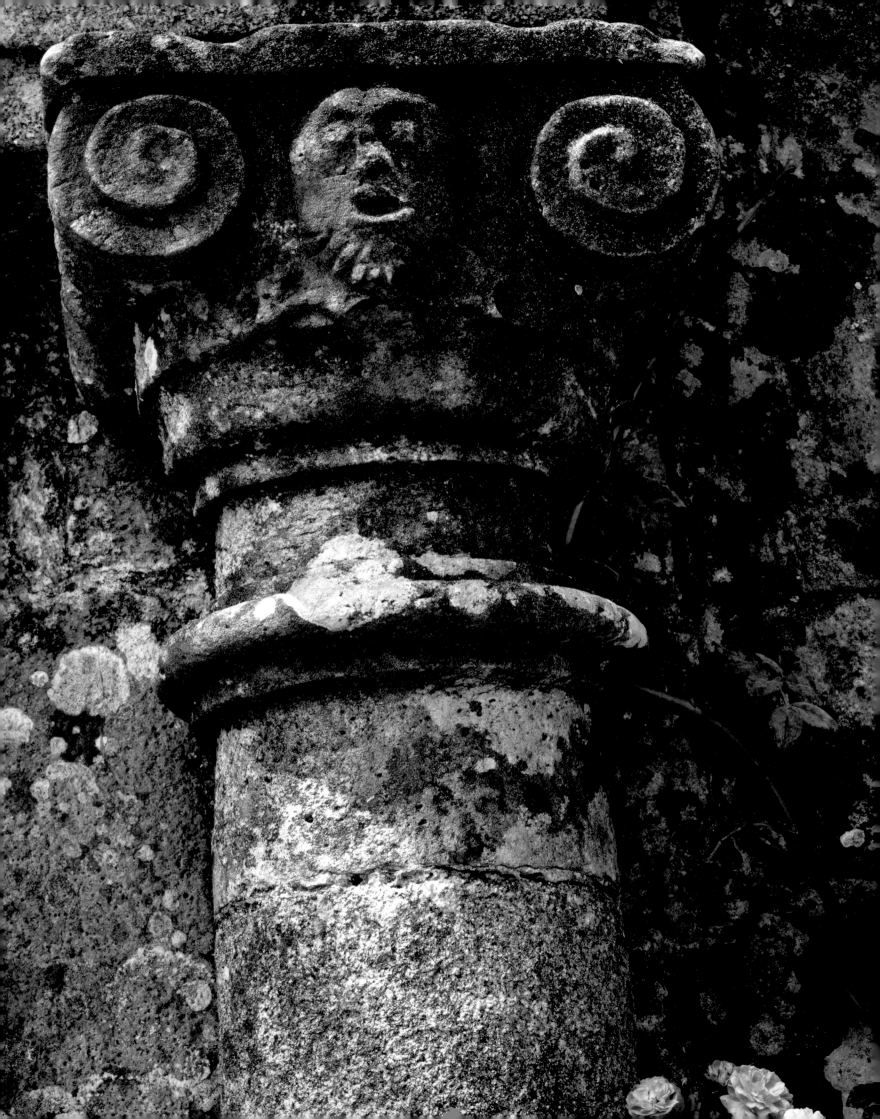

THE SLEEP OF REASON

The Hairy One of la Ferté-Bernard was a beast that had escaped the Flood. But one that Noah had forgotten to gather up in his Ark.

The Hairy One had contrived some resentment because of this.

As fat as an ox, with the head of a serpent, and a body that was an enormous egg covered with green fur, the Hairy One committed every evil deed possible. Unimaginable evil. She would eat sheep, if need be would munch on the shepherdess besides, and have Little Red Riding Hood for dessert; she would set fire to the harvest with her flame-spewing mouth; she would make the rivers overflow when she bathed. Oh, that filthy beast!

Our fears have become our pleasures. When the population of France consisted of only ten million subjects, she counted thirty million subjects of which to be afraid: forty million in all. (The account is there.) Gargoyles (serpents of monstrous size, said the *Nouveau Voyage* [New Voyage] of 1730, who used to wreak hideous carnage among men and beasts), Great Ghouls, Dragons, Two-Horns, Crust-Chewers, Graoulis, and Grotesque Demons—the repulsive children of France's sleep of reason. Today you are nothing but a dragon of canvas and cardboard that deliciously frightens the spectators of puppet shows and of the circus.

The retired Bogeyman has forgotten that he once was the Prince of Fear. He who used to terrorize grown men now barely makes children shiver.

Civilization begins the day that men have learned to close a door between the world and themselves. France has existed since the day that hunters (who weren't even our ancestors-the-Gauls yet) tracked bison, wolf, horse, and the wild bull in the forests that cover this hexagon (not even called Gaul yet). But France didn't *begin* until the day that, in the shelter of the first door—a tanned animal skin or a wicker enclosure made of branches and dried weeds—these same hunters inscribed on the walls of Lascaux, Cabrerets or Eyzies, other bison, wolves, horses, and cows, no longer made of skin, horns, and blood, but of pure and intelligent reference. For a civilization to be born, a door needs to be opened or closed, opened onto the immense and threatening or complicit universe, closed on man who conceives this universe.

Thus, the tales of Perrault tell the history of France before France even has a history. Little Red Riding Hood, already wearing the Phrygian bonnet of the Revolution, lives a drama with two characters, Madame la Chevillette and Monsieur Loup (Madame Peg and Monsieur Wolf). To be a Frenchman means to live in a country where people are beginning to be less frightened of wolves than of men, where a closed door ("Pull the peg and the latch will drop") allows the invention of devices, fables, and sentiments that will keep wolves at a safe distance.

And today wolves no longer roam around except in fairy tales, in La Fontaine's fables, in the names of regions —called Loudun, Louviers, Louveciennes, Loudéac, Louvignier, Luchapt, Chanteloup or the Vallée aux Loups. Wolves no longer play in every corner of the land except in the names of a hundred towns and a hundred thousand villages, where in winter it's cold enough for a wolf, where it is known that it's easy to fool a young wolf, and where everyone is hungry as a wolf when the time has come to sit down at the dinner table, behind the tightly closed door.

Yet, open this door anyway. France begins when you have crossed the threshold. France is on the other side. *Pull the peg and the latch will drop . . .*

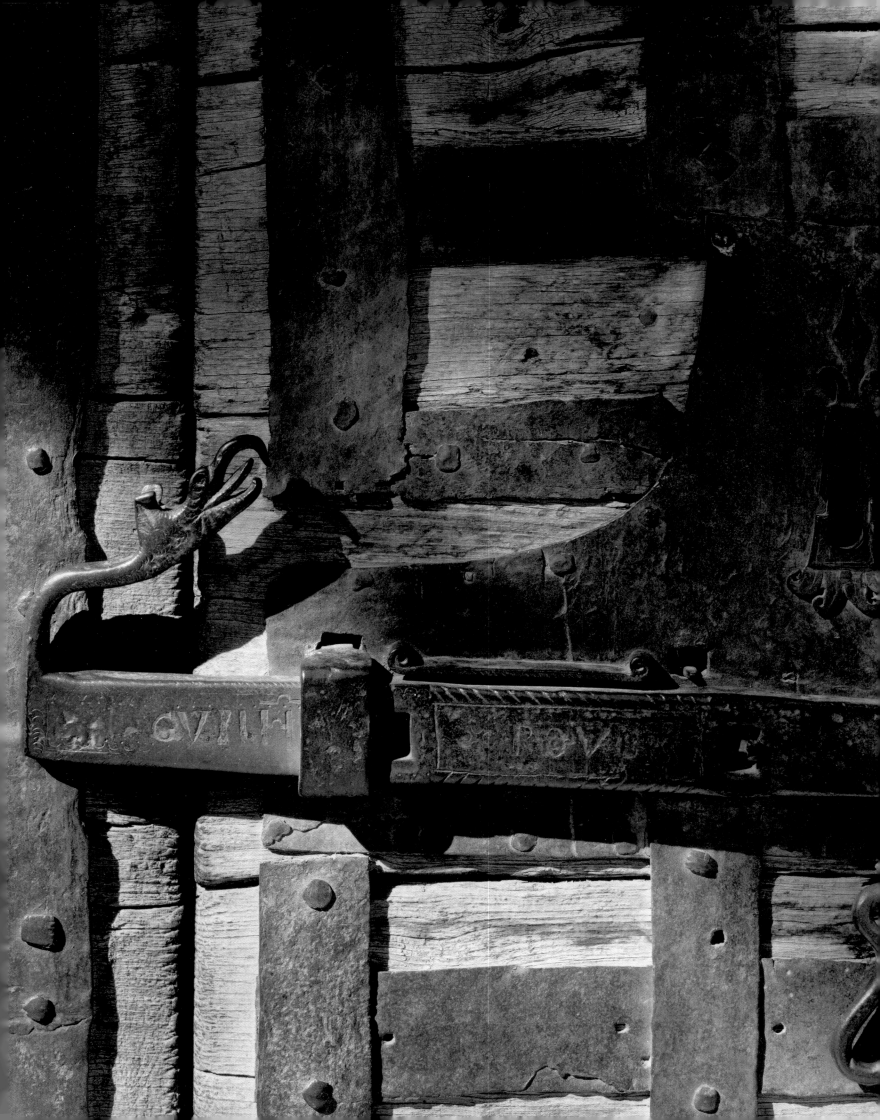

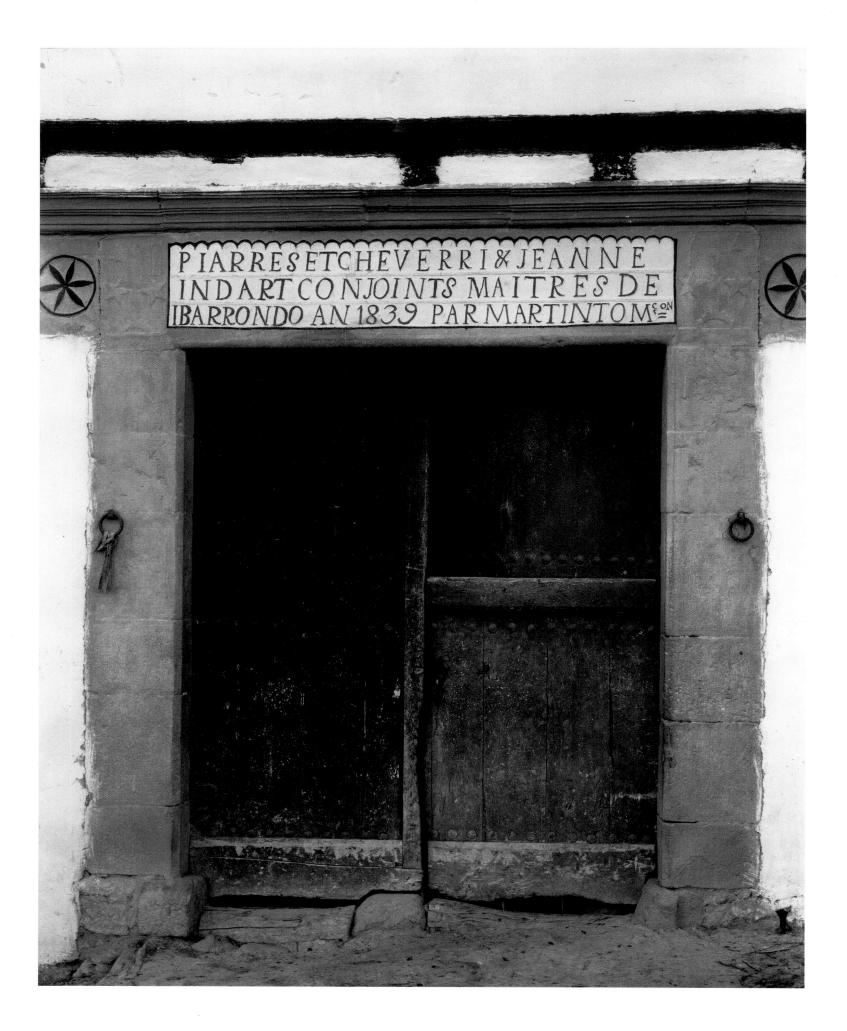

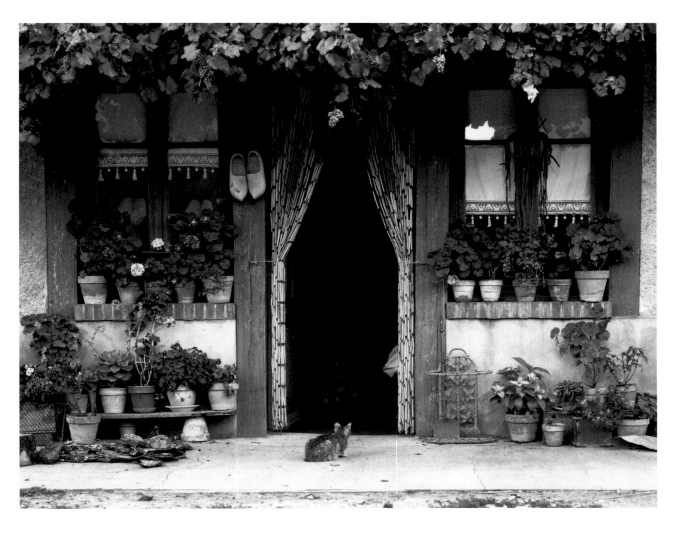

Essuie-toi donc les pieds, entre et fais comme chez toi,

dit la porte au chat.

Mais

le chat

ne dit rien

et reste sur son chat-à-soi.

La

porte

ne se ferme pas

pour si peu

La porte a l'esprit bienveillant

et

ouvert.

So, wipe your feet, come in, and make yourself at home, the door says to the cat.
But the cat says nothing and stays right where he is. The door doesn't close for such a little thing
The door has a very benevolent and open spirit.

THE FACE OF THE FRENCH

Undoubtedly there are other ways to visit museums than to leaf through them as though through a large family album. And there are other reflections to have when looking at the *Nativity* of the Master of Moulins than that of the family on Sunday calling out: "Hey, Zézette! Look at that fine fellow; that portrait is the spitting image of Uncle Etienne."

There is, however, a bit more wisdom in this remark than might appear at first, in the naive wonder of the Durand tribe in the land of masterpieces: it is true that the angel of Reims has exactly the same smile as cousin Juliette, that the Lady of Clouet and the woman who sells notions on the corner are as alike as two peas in a pod, and that French art wanders through the streets from the Black Virgins of the Auvergne on upward to the portraits of Degas. I know Jacqueline de la Queille, Countess of Aubigny, quite well; she was lady-in-waiting to Queen Eléonore, whose portrait Jean Clouet painted around 1532: she is the one who sells me vegetables every day, there where you see the sign *Aux Halles de Bourgogne* in my street of the same name. And I once was in love with that young girl of Renoir's, with the sunshine hair and the night-flowing gaze. She didn't know the painting, she had a different name, and will never know that young Monsieur Renoir, almost a hundred years earlier, had *already* loved her.

Race is not the sculptor of faces, but habits are. It isn't right to tell a people, as photographers did in the past: "Don't move, now—smile." The faces of a people are astir, as are mores, ideas, as are social systems and economic relationships. But through the movement of the shapes of the flesh, which is nothing other than the movement of souls, we like to see that fine obstinacy of French faces remain French. We like to find ourselves back again in a land among acquaintances, beyond the small swell of the centuries and the false night of time. We are grateful first of all to the shepherds of Fouquet, the ingenues of Watteau, the bourgeois of Daumier, and the young girls of Corot, for having allowed us *to recognize* them. We are comfortable with French portrait painters: we make ourselves at home. Indeed, we are at home.

Sometimes it is good to yell "Long Live France," but it is always helpful to turn those words around and say "France alive, lively, vivacious." France alive, like brisk water, vivacious like a smile that sweeps from face to face, lively as a spring that never tires of rising; that is the France that allows us to have an area of space or time, so much greater than we imagined, as our preserve or our garden of love. Not only do I tip my hat for the people in my village, I also take it off—Good day Monsieur Courbet—for any number of other passers-by, for that young Gallo-Roman man in Arles who is as

like my friend Jean Giraudoux as two drops of water (which one of them has been dead for a longer time?), for that bathing lady in a painting of the School of Fontainebleau, who resembles my friend Françoise Gilot like two drops of dew, for that portrait by Chassériau of Alice Ozy that resembles my friend Janine, a trapeze artist, like two rays of sunshine, for that profile in stone of a biblical lady on the western portal of Chartres that resembles Claire's face—a face of flesh and not of stone—like a shadow of the one who casts it.

To feel at ease in the past of France, as in history in general, one must hold both ends of the truth, one in each hand: nothing is ever the same, nothing is ever fundamentally different. The requirements of chronology and the delights of anachronism are complementary, not contradictory. It is certain that the winegrowing farmer of the *Très Riches Heures de Duc du Berry* had neither the same thoughts nor the same feelings as my friend Louis Precigout, winegrowing farmer in the mid-twentieth century in the village of Marancheville. The distance separating the medieval plow from the modern tractor does not only define a difference in exterior conditions, but it also corresponds to a difference in interior viewpoints. There is a great deal more that is new under the sun than the limited stammerings of proverbs might indicate. But nowhere is man a stranger to man. This is true in space, it is true in the duration of time. And while playing cards with Paul Strand's photographs, I am not aware of playing a frivolous and futile game when I marry the little twelfth-century Eve to the young carpenter of today, when I confront the old wooden Christian saint of Brittany with the fisherman now retired. On the face of the old man, the wear and tear of time imitates the gnawing of the centuries' erosion on the wooden mask of the eight-hundred-year old saint. In the card game of man's *constancy*, it is always an accomplishment one undertakes and achieves.

I like bringing you together within the same circle of friends, all of you good people of eight hundred years ago, fine people of just eight days ago, young ladies of Chartres so rigid in stone, young women of Paris so full of laughter in the Tuileries Gardens, foolish virgins and wise virgins, dead for ages or very much alive in the joy of your body. The homeland is where all people resemble each other magnificently and are abundantly different. The homeland is the people one loves. I live in a France that is not only a great rendezvous of people who very much exist, but also a beautiful crossroads of those both absent and present. One must live one's period, one must love it deeply. But how poor we would feel if we were contemporary only with our contemporaries.

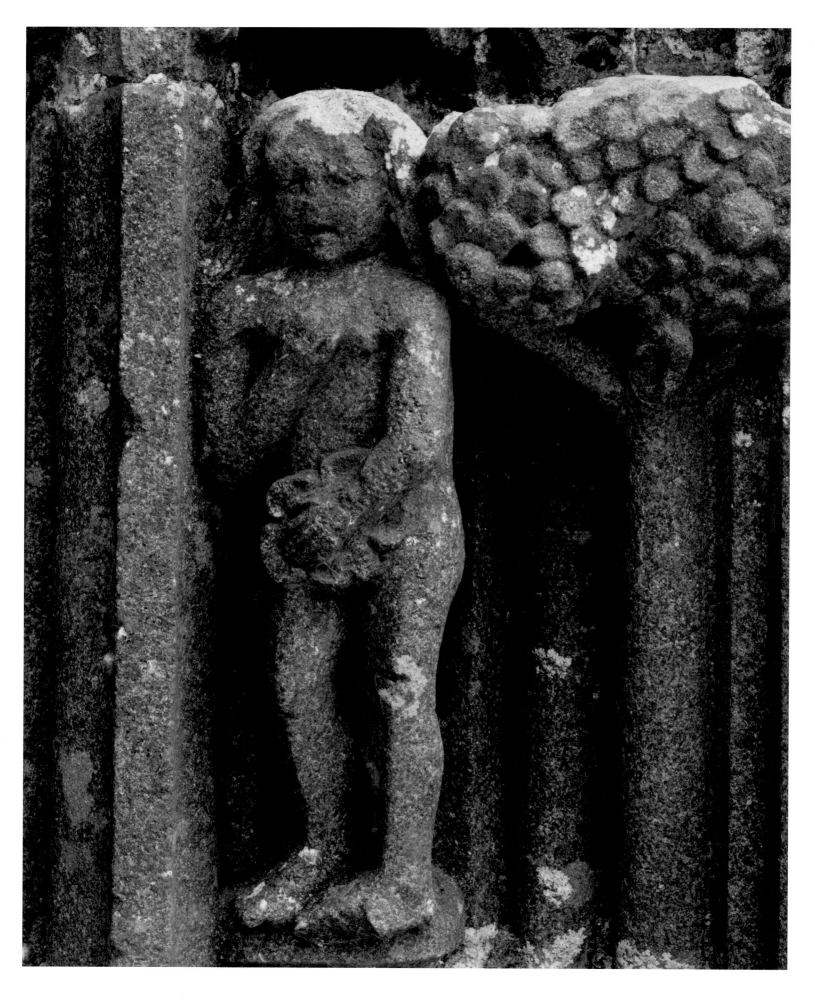

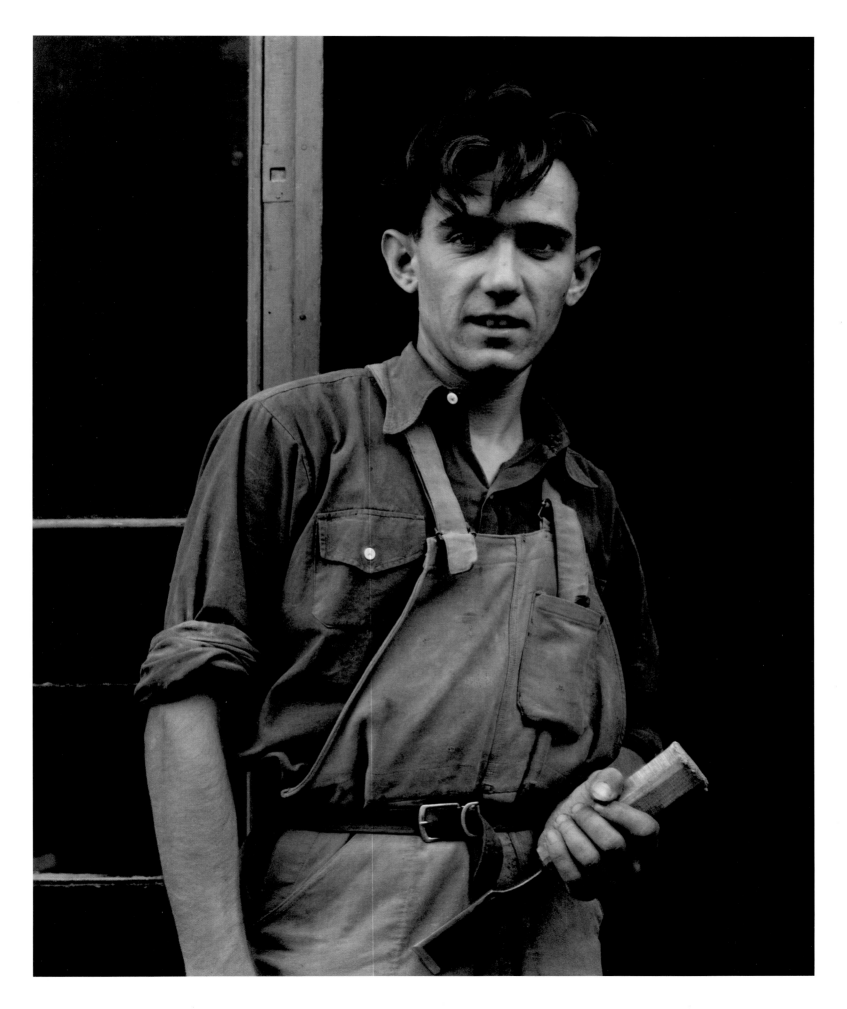

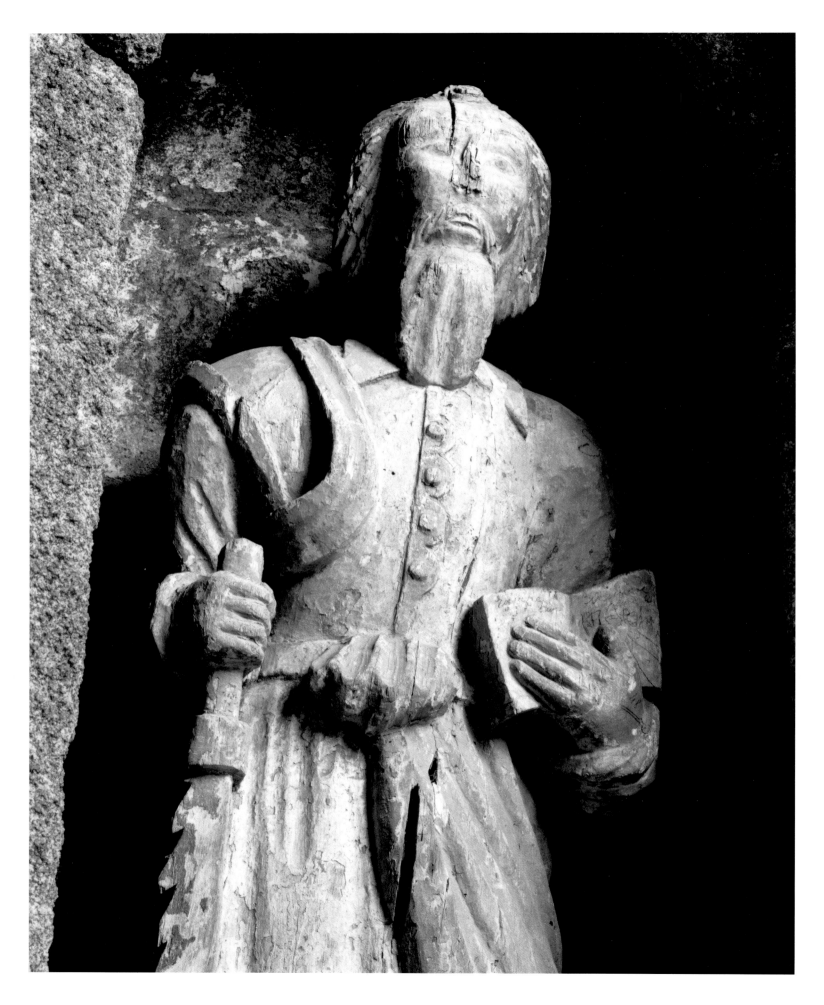

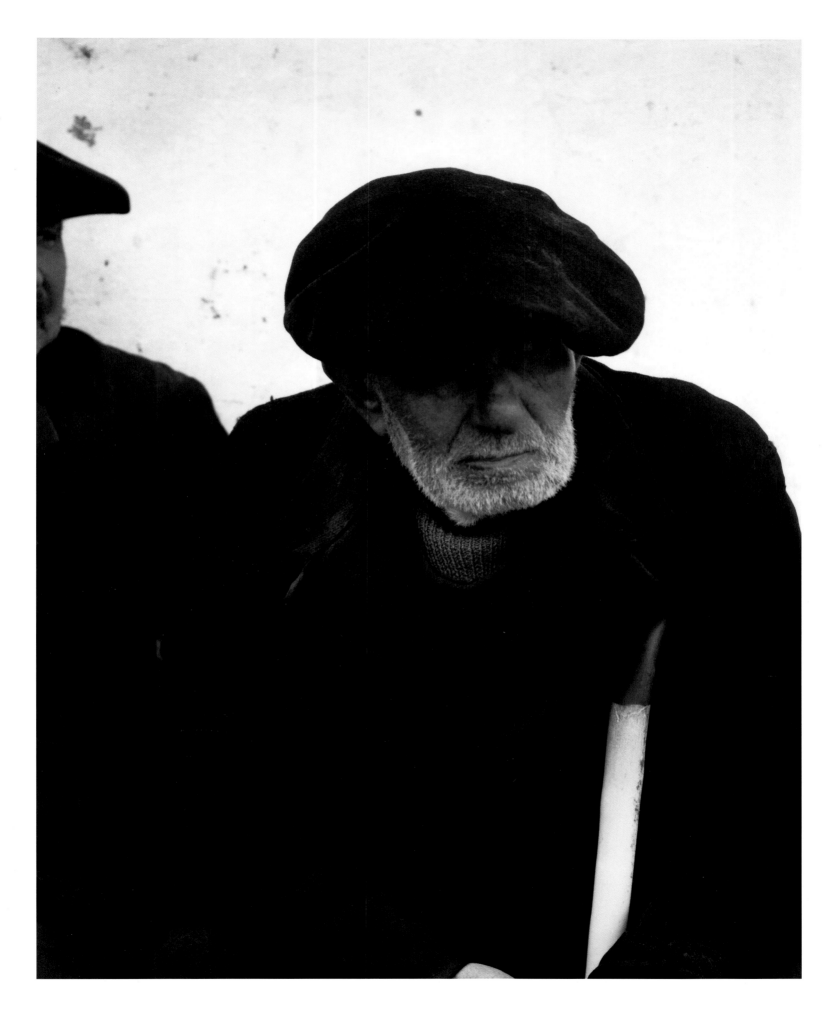

THE HERALDRY OF FRANCE

One should speak Spanish to God, Italian to women,
French to one's friends, English to birds, and German to horses.

—Charles V

ENGLAND

The Italian is wise before he does something, the German while
he is doing it, and the Frenchman when it is done.

PORTUGAL

Portugal é um ovo, a Hispanha uma peneira, a Franca uma eira.
Portugal is an egg, Spain a sieve, France a sphere.

GERMANY

Er lebt wie der liebe Gott in Frankreich.
He lives in France like the sweet Lord.
Die Franzosen sprechen so schnell wie Kaffeemühlen.
The French speak as fast as a coffee-grinder.

HOLLAND

Hij leeft als God in Frankrijk.
He lives in France like God himself.

RUMANIA

Vorbaret ca un Francez.
Chatty like a Frenchman.
Francezul este ca soricelul, Englesul ca broasca.
The French are like mice, the English like frogs.

ITALY

Gli Spagnoli s'accordano á bravare, i Francesi a gradire, gli Inglesi a mangiare,
i Tedeschi a sbevazzare, e gli Italiani a pisciare.
The Spanish agree to act bravely, the French to please,
the English to eat, the Germans to drink, and the
Italians to piss.

SPAIN

Italia para nacer, Francia para vivir, Espana para morir.
Italy to be born in, France to live in, Spain to die in.

GREECE

τὸν Φράγκον φίλον ἔχε, γείτονα μὴ ἔχης.
Take a Frenchman as a friend, not as a neighbor.

EPIC POEMS OF HEROICS AND THE HEROICS OF SONG

"Nothing but foolish ditties," says the serious gentleman who doesn't want to be fooled. Therein lies the wisdom of the wife of Monsieur Jourdain. She has only one answer for her husband: "I tell you, those are songs."

Yet, it is songs that paint the portrait of a country with the greatest likeness. Trees and cathedrals are the sons and daughters of the land. But song is the daughter of the air. The air of France engenders those couplets that seem, more than anything else does, to be French, that are French to every melody, to the melody of *Marlborough s'en va-t'en guerre* (who did not return from war), and to that of *Roi Renaud* who did, indeed, come back.

The history of France is accounted for with dates, the history of the French is counted out with counting rhymes and recounted with sad accounts. The rhythms of work, of life, and of death are transferred to the rhythms of songs. Songs of farming and cultivation of the Central provinces move with the slow step of the oxen. Pastoral songs develop on the 6/8 beat that is the very rhythm of the shepard's daydream. Work songs take on the cadence of the craft, are arranged according to the gestures of the sawyer, the woodcutter, the weaver. The lullaby rocks and the lament moans.

The historian tells us about kings and marshals. The singer tells us about the king's son and the shepherdess, the pleasing drum and the poor soldier.

Pretty songs, from where do you hail? And it is a song that gives the answer:

> *"Beauty, where were you raised?"*
> *"I'm from France, the highly praised,*
> *And of most noble birth.*
>
> *My father is the nightingale*
> *Who sings up in the tree*
> *On branches of the finest girth.*
> *My mother is the mermaid hale*
> *Who sings in the salty sea*
> *With its shores the highest on earth."*

To the extent that one probes the lovely forests of the songs of France, one discovers that what is most essentially, most artlessly French in them, is also fundamentally international and universal. In Lower Berry I have heard children sing as school let out:

I saw a cow
Dancing on the ice
In the heart of summer
"Dear fellow, you tell lies."

I have crossed the sea, crossed a continent and in a small village in Texas I heard kids sing:

I saw Jack Rabbit
Dance the polka on his hands
By the side of my road
"Don't lie, buddy, don't lie."

In the Piedmont, the cantilena *Ohi mamma, mett'm in nanna!* is exactly the same as our *Roi Renaud*. The song *C'était une boiteuse en allant au marché* (It was a lame lady who went to market) is found in all three points of a triangle: Finistère, Wallonie, and Val Mustair. Michel Leiris traveled thousands of miles to collect the secret songs of the Dogon of Sanga in Mali. They are quite beautiful and seem very strange. But not as strange as all that. To the African who hums: "*She isn't of the earth—She isn't of the sky—she has little ones—It is the grasshopper,*" the farmer from Yonne (unknowingly) responds with "*Who is passing through the woods—Without tearing her silken gown?—It is the sun!*"

The poems of Hesiod send us abruptly back into a distant, a very distant antiquity. But a round sung by little Greek girls two thousand years ago brings us right back to the corner of our street, where the little girls in primary school sing the same lyrics as their great-great (and still further back) grandmothers from Attica.

Scholars will tell you that songs travel, that they run and run, like the ferret, and that if they are alike it is because they passed this way and that. Perhaps. But I also believe that the songs of the entire world are sung to the same melody, which is a family melody, that all people are much more dissimilar than we believe and much more alike than we think. Coming from far and wide, laughter and grief make a country of familiarity. If I watch France singing in profile, I am watching mankind of every sort head on.

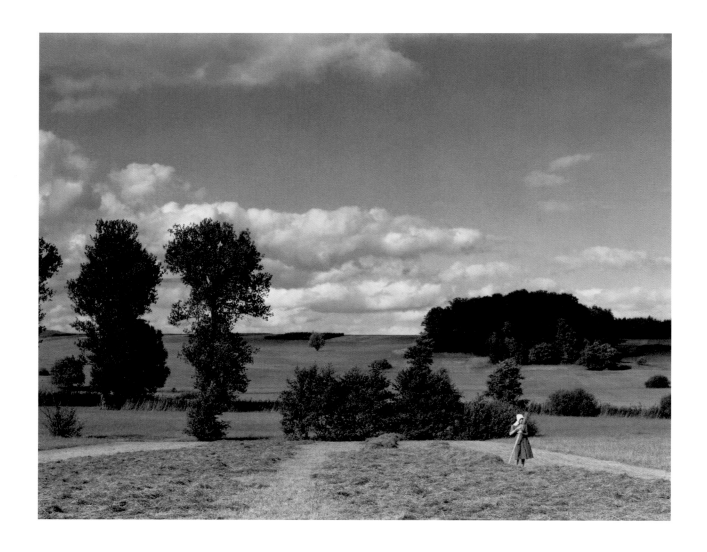

Behind us, here, there is a great mountain
My lover and I, we often climb up

Going up is very difficult
Coming down, relief a thousandfold.

Behind us, here, the nightingale sings
All night and all day from morning's break

In his sweet language he always repeats
That lovers too oft are unhappy.

The sickness of love is a serious malady
No doctor can take it away.

If the mountain were suddenly cut to the ground
I'd build myself another at once.

Here then is Pentecost—Pretty Lauly
Strawberries halfway up the sweet woods
Strawberries halfway up the sweet woods.

New roses here—they've bloomed again—
It's the time when young beauties change lovers.

Will you then change yours—oh Pretty Lauly?
No, not another I want—none but my own.

The summer's roses wither—The strawberries will too
Everything is changing—My heart alone will not.

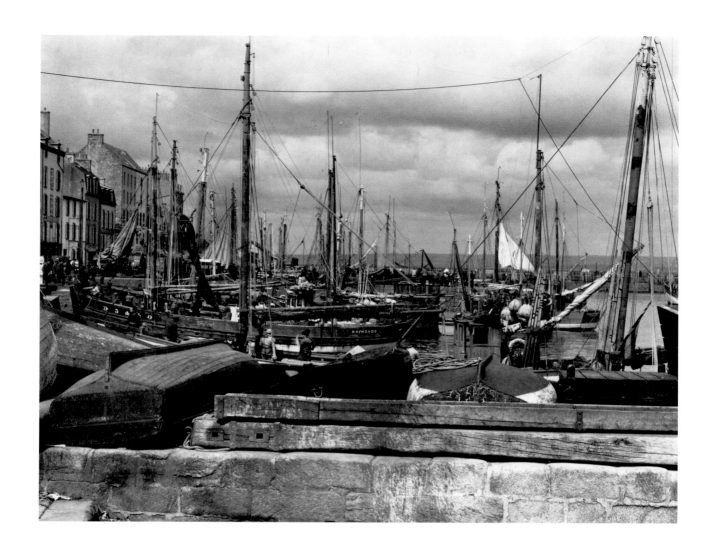

It's the girls of La Rochelle
Who've rigged a seafaring ship
To go off and run a race
In the midst of the sea of Levant
Ah! the leaf is flying off
Ah! the leaf flies off in the wind.

I plucked the snow-white rose
That went off, sails to the wind
She departed, the wind at her back
She'll return beating to windward
Ah! the leaf is flying off
Ah! the leaf flies off in the wind.

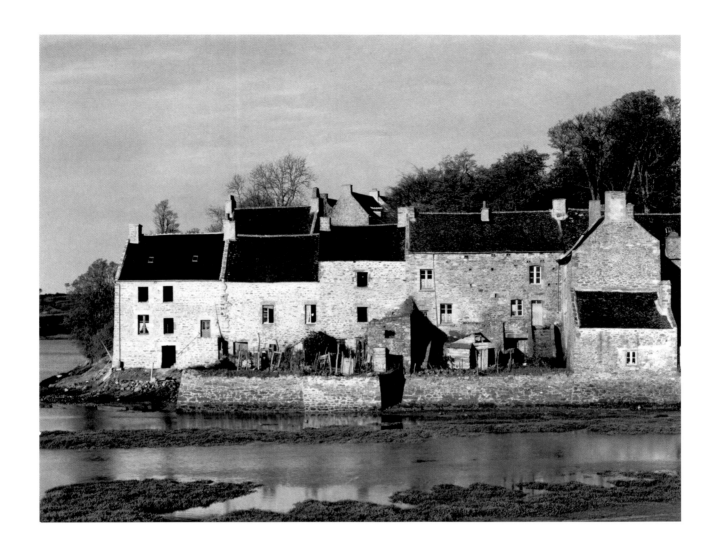

Behind us, here, there is a pond,
Where three fine ducks are swimming

The son of the king goes off to hunt
With a handsome rifle of silver.

He aimed for the black duck, the white one he killed,
"Oh! you the king's son, for shame

You have killed my white duckling,
Who's losing his blood from under his wing

And diamonds he's lost from his eyes
And gold and silver from below"

"What will we do with all this wealth?"
"To the convent we'll send the young girls

We'll send the young girls to the convent
And to the regiment the boys will go."

GOD WRITES STRAIGHT WITH CURVED LINES says a proverb from Franche-Comté. That is because God and nature write by hand. Man, who writes by machine, has invented the straight line, the shortest path from a thought to an act. He takes things as they are, wholly rounded, and returns them geometrical, transformed into what they are not. Of the landscape, suggested to him with its curves and circles and spirals, he makes regular figures that he imposes. Born clever, the Frenchman is a thinking reed who thinks in squares and in triangles. The mason who lines his façade with stone, the farmer who stacks his hay, the miner who climbs his slag heap are the first Cubists. Naive painters, who describe the universe of curves with straight lines.

THE OPEN WINDOW

How clever people are. To find shelter from the wind and to thumb their nose at bad weather, they invented walls and constructed houses. But to say hello to the sky and shake hands with the sun, they opened windows. To foil the cold and the heat, they manufacture casement windows, to foil light and dark they manufacture windowpanes, and to live against all odds they close the shutters. How clever people are, they invent handles to close the shutters, they invent pegs, clamps, latches, swivels, and sashes, hooks, links, and door-bolts. How clever people are. They put things together with miters, mortise and tenon joints, tongue and groove. They split and plane wood, re-rabbet, line out, and then join the pieces. And when they've done all that, as they lay down their clamps and bolts, their planes and buffing wheels, their hammers, as they leave the workshop, the tracing iron, and the marking gauge, they open the window, put flowerpots on the sill, an onion on some wire, and think that all's well with the world. How clever people are.

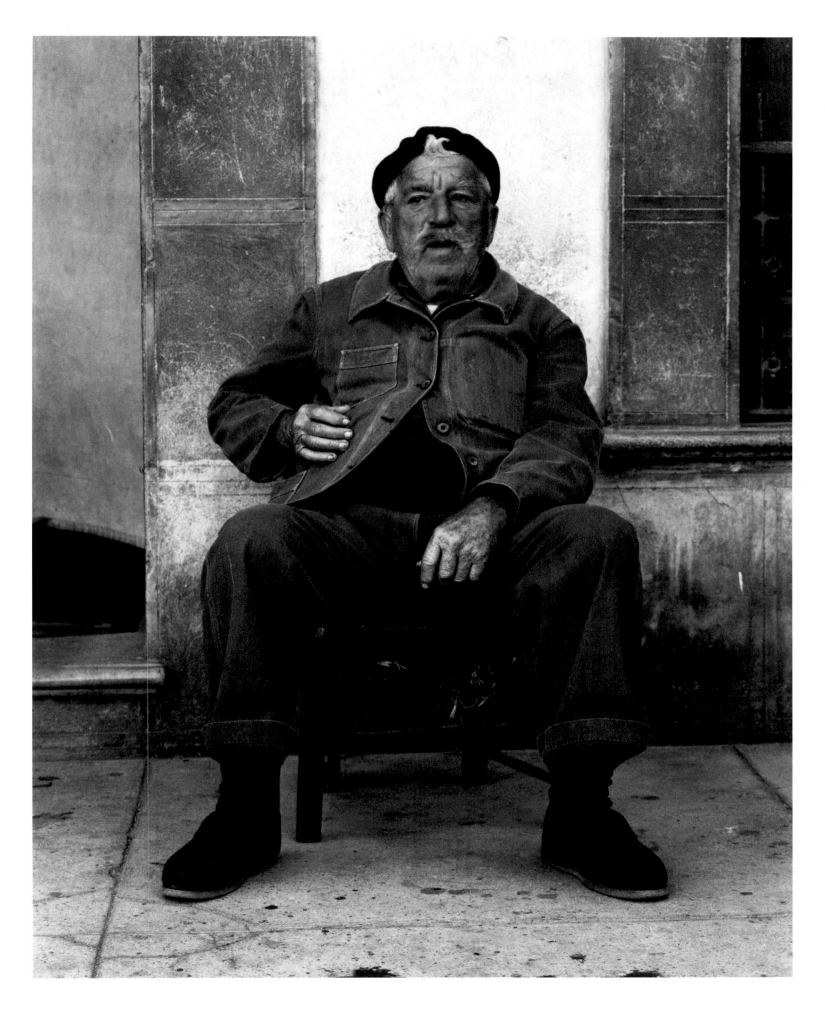

THE WISDOM OF IDEAS

THE MOUSE THAT KNOWS ONLY
ONE HOLE IS QUICKLY CAUGHT.

AN OLD STOVE IS EASIER TO HEAT UP
THAN A NEW ONE.

A KEY THAT IS USED
IS ALWAYS WORN THIN.

TO EACH BIRD HIS OWN NEST SEEMS BEAUTIFUL.

A YOUNG WOMAN SOFT BREAD AND GREEN WOOD
THE HOUSE IN THE DESERT DO PUT.

YOU TEASE THE TROUT
TO CATCH IT MORE READILY.

THE CHICKEN NEVER DRINKS WITHOUT
RAISING HER HEAD TO THE SKY.

IT'S MEAN TO TAG CICADAS
AND TO PLANT VINES IN THE SEA.

WHEN THE SHEEP HAVE BEEN COUNTED
THE WOLF WILL EAT THEM.

THUNDER IS THE DRUM OF THE SNAILS.

THE HAUGHTY GETS DRUNK
ON HIS OWN BOTTLE.

TODAY A KNIGHT A FRIEND MARRIED IN BLOOM WELL-FED
TOMORROW A COW-HERD AN ENEMY MOURNFUL IN TEARS IN BEER.

NOTHING DROPS INTO
THE MOUTH OF THE SLEEPING FOX.

NOT ALL THAT GLITTERS IS GOLD
NOT ALL THAT'S WHITE IS FLOUR.

WHEN A DOG IS DROWNING
EVERYONE OFFERS HIM SOMETHING
TO DRINK.

THE VINE AND THE PEAR TREE
THE GIRL AND THE PEACH TREE
ARE NOT EASY TO GUARD.

The faith of the coalman consists of seeing the Lord Jesus Christ as a poor man, all black, carrying his sacks, bent over beneath his Calvary of filth and charcoal. The religion of the French is a legend gilded with solace and misery. From Arnoul Gréban to the *Cantique des mariniers d'Antibes* (Song of the bargemen of Antibes) which probably dates from the eighteenth century, the Holy Family is first and foremost a family that has suffered a great many misfortunes in which everyone recognizes his own.

The Holy Virgin, in art, in poetry, and in the commonly shared heart of the French, will never be done weeping all the tears her body holds. And do you know why she weeps? She doesn't merely weep over her own sorrow. She doesn't merely weep her own tears, she weeps everyone's tears. "*Religious anguish,*" says a philosopher from Trèves, "*is the expression of real anguish and the protestation against real anguish. Religion is the sigh of the devastated creature, the heart of a heartless world.*"

The Holy Virgin Mary
I'm weeping there, oh son of mine,

Goes off across the fields
For all the poor and destitute

Who must work behind the plow
Why do you weep my mother?

In every kind of rain and wind.
Why are you weeping so?

SONG OF THE BARGEMEN OF ANTIBES

In honor of Notre-Dame du Bon Port

Holy Virgin; hear our prayer,
Our every hope lies in you.
Dear Lady who stands Watch.
Most worthy Mother of God,
Be our shield and our protection
And defend us anywhere.

If you deign to care for us,
We can venture anything.
Any effort the Turk makes on us
We shall defy him every time,
We shall fight his daring off
Through your invincible support.

We shall be well beyond all dangers
In the face of his weightless ships,
And in spite of all his fury,
We shall brave the Crescent Moon
And all of Barbary
Under your most forceful arm.

May not one scourer of the seas
Be able to dismay us;
May our vessels and our galleys
And any of our other ships
Despite all the buccaneers
Peacefully continue navigation.

When a loud and clamorous gale
Is pushed on by the northern wind,
When the thunder snarls and growls
And it seems that all will perish,
Hasten then, Queen of the world,
To come and rescue us.

Hold with your arms
Both our topsails and our masts,
Strengthen every rope we have,
All our cables and our shrouds,
To let us stand up to the storm
Amidst the fury of the winds
Brightest Star of the sea,

Show yourself when danger's near,
In the darkest of the night
Serve as beacon and northern light
To those who, under your watchful eye,
Have every hope to make the port.

At every moment of the day
Preserve our poor ships;
Let none of them fail
When reefs and waves
Cause captain and sailors
To tremble from stern to prow.

If the anchor should drift off
Keep us all from being hurt;
Save our anchor, Lady dear,
Help us in our feeble venture
And give us the ability
To guide us safely back to port.

Open wide the boatman's eyes
So from afar he sees the rocks.
And when the white-haired waves
Make the ship leap high and low
From deepest down to highest sky,
Come quickly to lend us your support.

Preserve for us our mizzenmast,
The compass and the rudder too,
When we're in direst jeopardy
At the mercy of the winds and waves;
And send us, too, the lovely Moon
To serve the needs of sailormen.

Never allow it to befall us
That the peace between us shatter;
Chase away, oh gentle Mary,
From port and starboard, too,
All trouble and all shouting,
And keep us jointly close.

Each of us is most regretful
To have sinned so frequently.
Oh Lady, good and watchful,
Make us always to remember
That God sees us everywhere
So in the future we'll act better.

Preserve the health of each one of us,
Preserve our life and liberty.
You are able, Heavenly Virgin,
To spare us night and day,
Spare us from war and from the plague,
From all that to us harmful be.

Beseech your beloved Son for us
That he may bless our daily gain;
And add to our protected passage
A glad and prompt return
And we shall always bring you homage
With every sentiment of love.

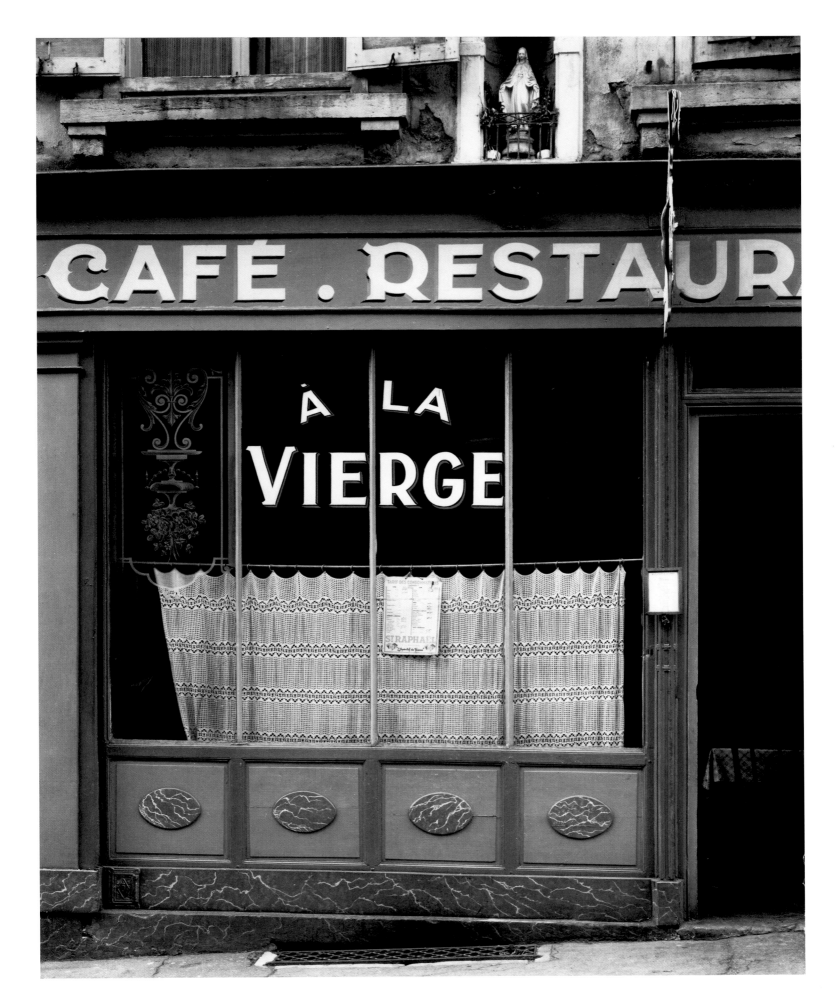

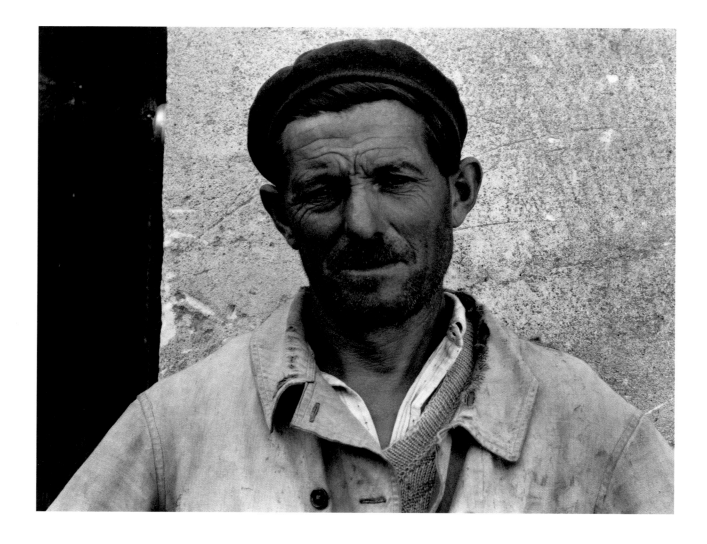

Ordinarily, people who speak about the French farmer can be divided into two categories, neither of which makes any sense at all. For one group, the farmer is he who carries out the venerable *gesture of sowing*; he is a kind of tree that teaches us a lesson in wisdom, in resignation. The Eternal Farmer, in tune with the rhythms of the seasons, submissive to the Great Immutable Laws of nature, off he goes to the music of bagpipes and bombardons, and let that be an example to you, innovators, agitators, forward movers, progressives, philosophers, and so on.

As for the other camp, there are only *certain unsociable animals, male and female, bound to the soil through which they dig with unassailable tenacity*, and so forth.

The sublime farmer and the loathsome one, the puppet praised by every let's-go-back-to-the-soil-that-never-lies and the one that's ridiculed by city-dwellers—the Wise Man of the fields, celebrated by regionalist,

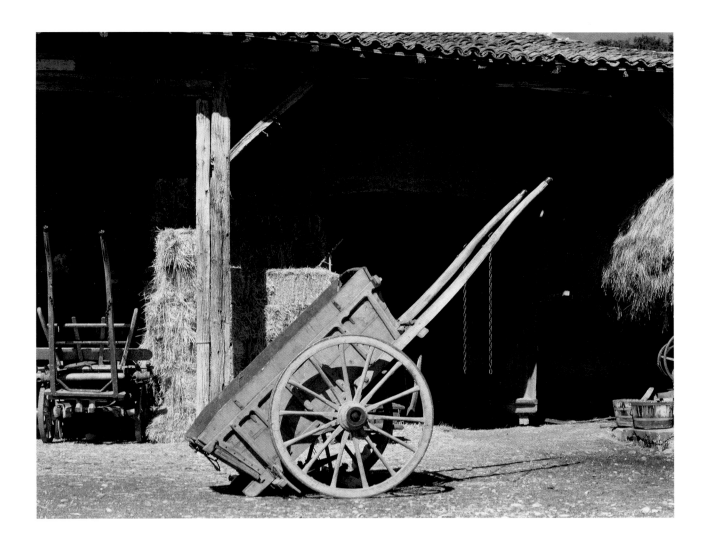

folkloric, and buco-lyrical writers, and the Country Mouse, pitied by La Bruyère, derided by Maupassant, treated like a country bumpkin by the City Mouse—two faces of the same mistake.

The farmer works the soil. It is not so much he who is shaped by the earth as the earth that is shaped by him. The land makes the farmer who in turn gives it all back.

The only occupation that endures is not the one of the lords of war, it is that of the lords of the earth, gentlemen of the plowshare and the plow, depicted in the *Très Riches Heures du Duc de Berry*, painted by Louis le Nain, and lovingly photographed by Paul Strand. The history of the French farmer is not that of a ceramic statue, unchangeable across the centuries. It is the history of progress in tools, which trace the curve of human progress. From the hoe to the ard plow, from the ard plow to the plow, from the single plow to the multiple plow pulled by the tractor, the farmer becomes what he makes nature become: different. That does not mean unfaithful.

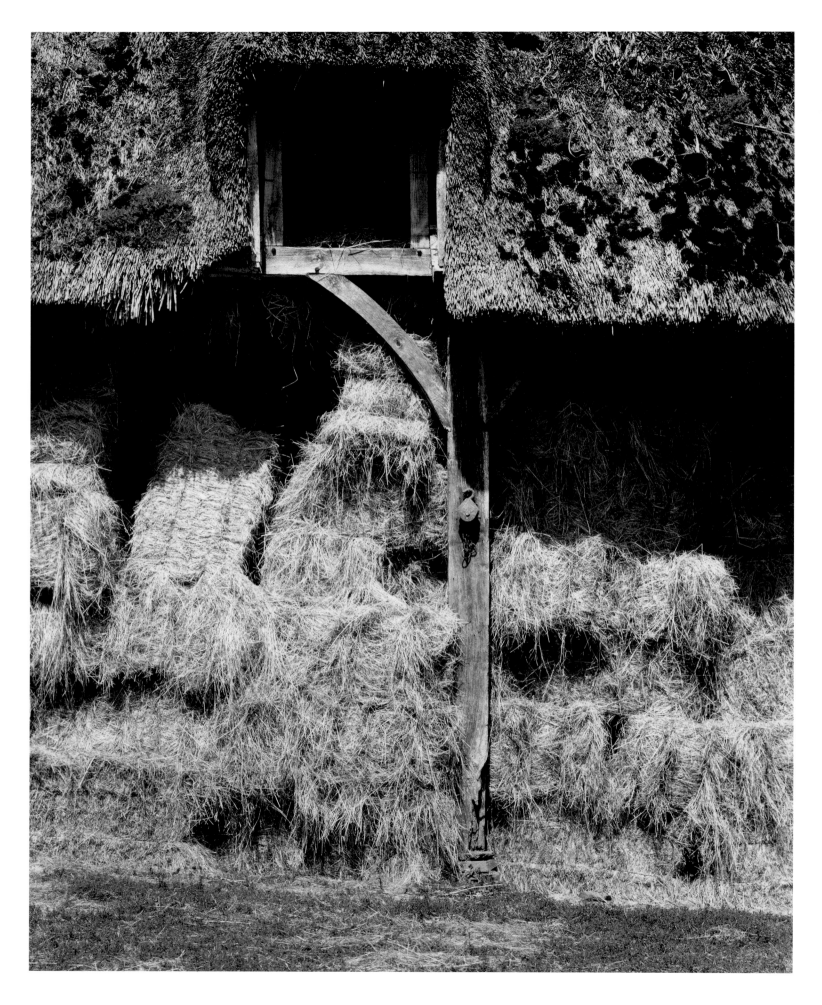

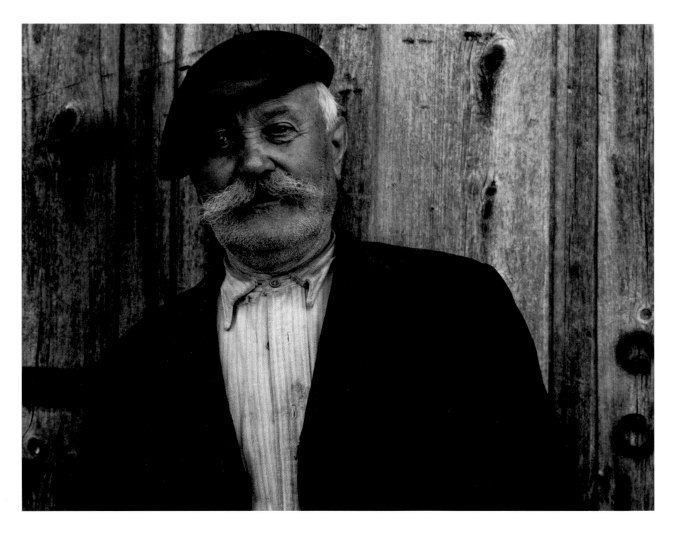

L'homme de paille

Il avait tellement longtemps
semé le grain coupé la paille
lié les gerbes de froment
gelé au froid nu des semailles
brûlé au soleil saoûl de l'août
Il avait tellement longtemps
battu le blé couru la route
entre les greniers et les champs
Il avait tellement longtemps
reçu la pluie reçu la grêle
subi la neige et le grand vent
germé de chaud séché de gel

qu'il était devenu de paille
belles moustaches de blé lisse
menton de chaume qui piquaille
soncils de mil barbe en maïs

(Il faut prendre extrêmement garde
à ce qu'on fait dans son travail
ou bien l'on devient par mégarde
d'homme de chair homme de paille)

Proverbe :
Être comme un rat en paille
Manière de parler figurée, pour dire : être à son aise

The Man of Straw

For so long he had
sown the seed and cut the straw
bound the wheat
frozen in the naked cold of seed
burned in the drunken August sun
For so long he had
lashed the grain and run the distance
between barns and fields
For so long he had
yielded to rain yielded to hail
yielded to snow and the arduous wind
sprouting with heat dried up from the frost

that slowly he turned into straw
fine mustache of silken wheat
chin a prickling thatch of stubble
eyebrows of millet and a beard of corn

(You really should watch out
for what you do in your trade
or else inadvertently you go
from man of flesh to man of straw)

Proverb:
To feel like a rat in straw
A figurative way of saying: to be at ease

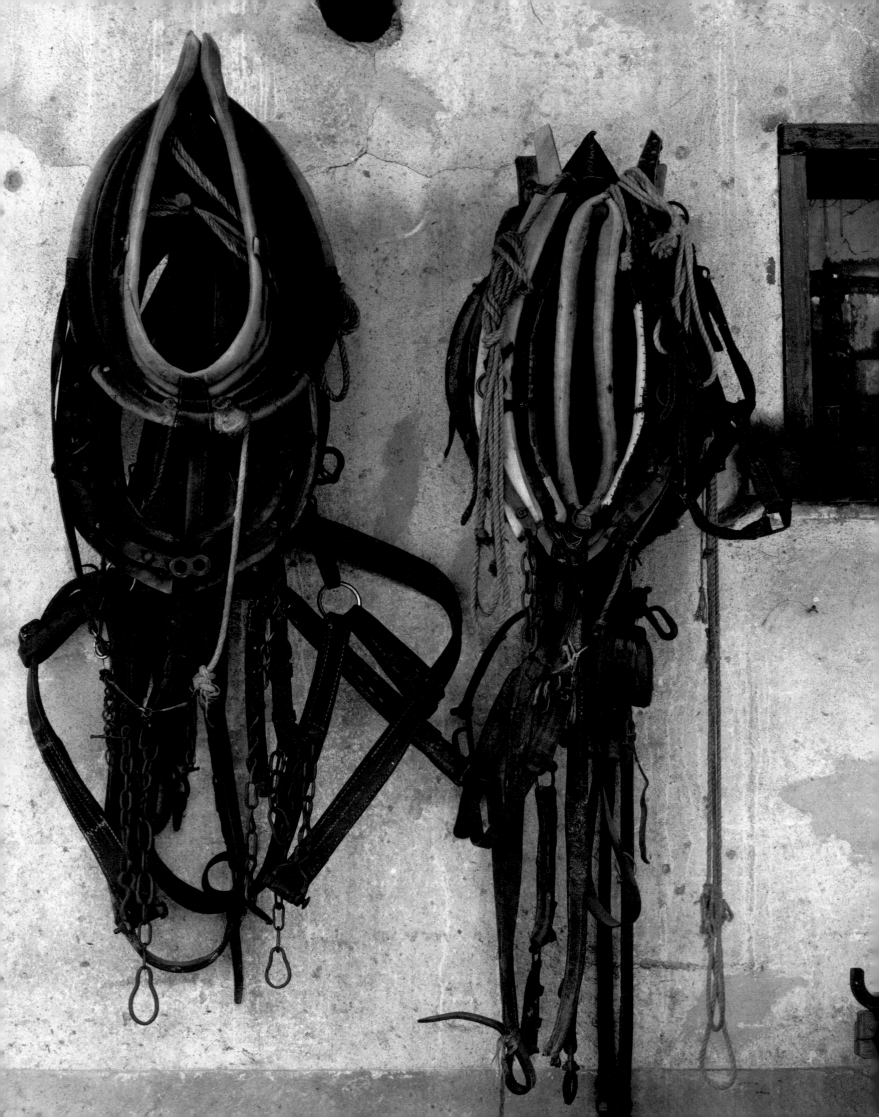

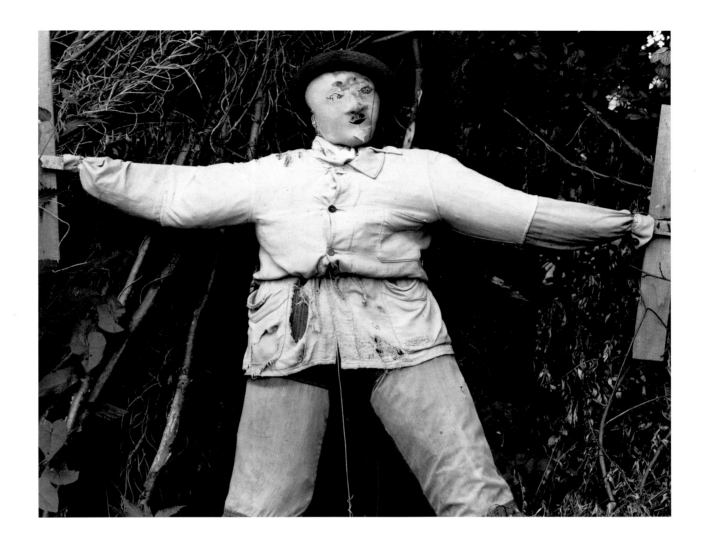

THE YEAR OF THE FARMER

JANUARY

January cold and inert
On her eggs chills the blackbird.

On Saint-Vincent's day
Winter comes right back
All's frozen or all's cracked
Or breaks a tooth away.

Flocks of birds searching for pasture
A sign that it's colder than last year.

FEBRUARY

The snow that in February falls
Away with its foot the chicken hauls.

On Candlemas Day
When the sun goes its full way
The bear returns to its cave.

February that snow fetches
A fine summer to us pledges.

MARCH

In March we build a fire
of wooden dolls
Three charred sticks
and one small log.

March with hammers
April with knives.

Rain in March
Isn't worth a fox's piss.

APRIL

April is not so sweet and frail
That its bonnet can't be
made of hail.

If it thunders in April
The poor ought to revel.

If the wind blows on
Saint-Prudence Day
The sheep will dance
the night away.

MAY

A rainy May will marry well
The farmer and his demoiselle.

If it freezes on Saint-Angele's Day
Everything can be thrown away.

JUNE

When the cat rubs its ear
Good weather is coming near.

On the day of Saint-Claude
you must hush
And bless the gift of
cornmeal mush.

Morning rainbow
Moves the mill.
Evening rainbow
Waters the sill.

JULY

A year of cherries red
Puts a smile on every head.

On Madeleine's Day
the nut's full and yellow
the blackberry mellow.

Red in the evening,
white in the morn
Is for the pilgrim all day long.
White in the evening,
red in the morn,
Makes the mill go round and round.

AUGUST

When in the summer
the tall roosters drink
The rains come suddenly,
no need to think.

He who in August sleeps
Is the one who later weeps.

From Saint-Laurent to
Our Lady's Day
The rain does not anyone
hurt or dismay
But when it comes to
Saint-Bartholomew
Scorn comes from all
but a very few.

SEPTEMBER

Sheep who graze in the sky
Bring windy weather
and not dry.

When the onions have
three layers of skin
It's a sign of cold coming in.

On the day Saint-Clou is hailed
It's time for the lamp
to be nailed.

OCTOBER

On the day of Saint-Denis
The wind and midnight shall marry.

Snow to the firebrand
When Saint-Simon
is in the land.

Relatives, like wind and rain
After three days become a pain.

NOVEMBER

So many hours of sun on
All Saints Day
So many weeks that the cold
won't stay away.

If the winter goes its merry way
It begins on Saint-Martin's Day.

The sun on Saturday
especially
Makes a perfect curtsey.

DECEMBER

The miles are doubled
in winter time
And no forest green or even lime.

The good Saint Nicholas
Marries the girls
to fine young lads.

On the day of Saint Thomas' feast
Bake your bread and wash your sheets
Barely will the work be done
Then the day of Noah
has come.

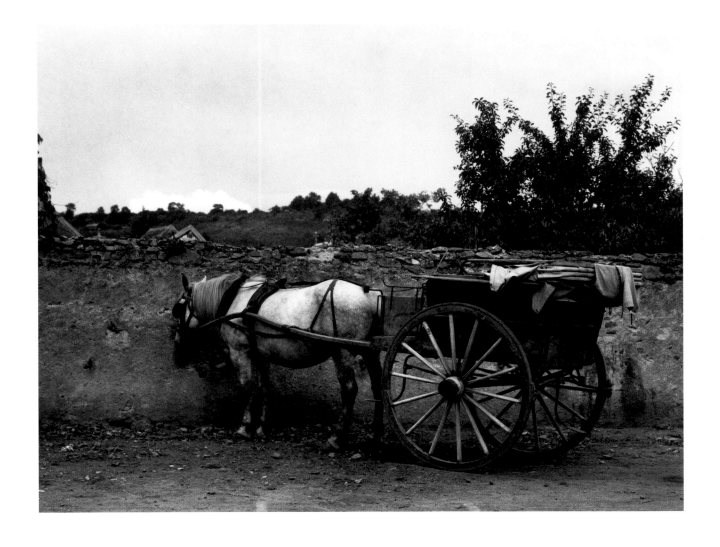

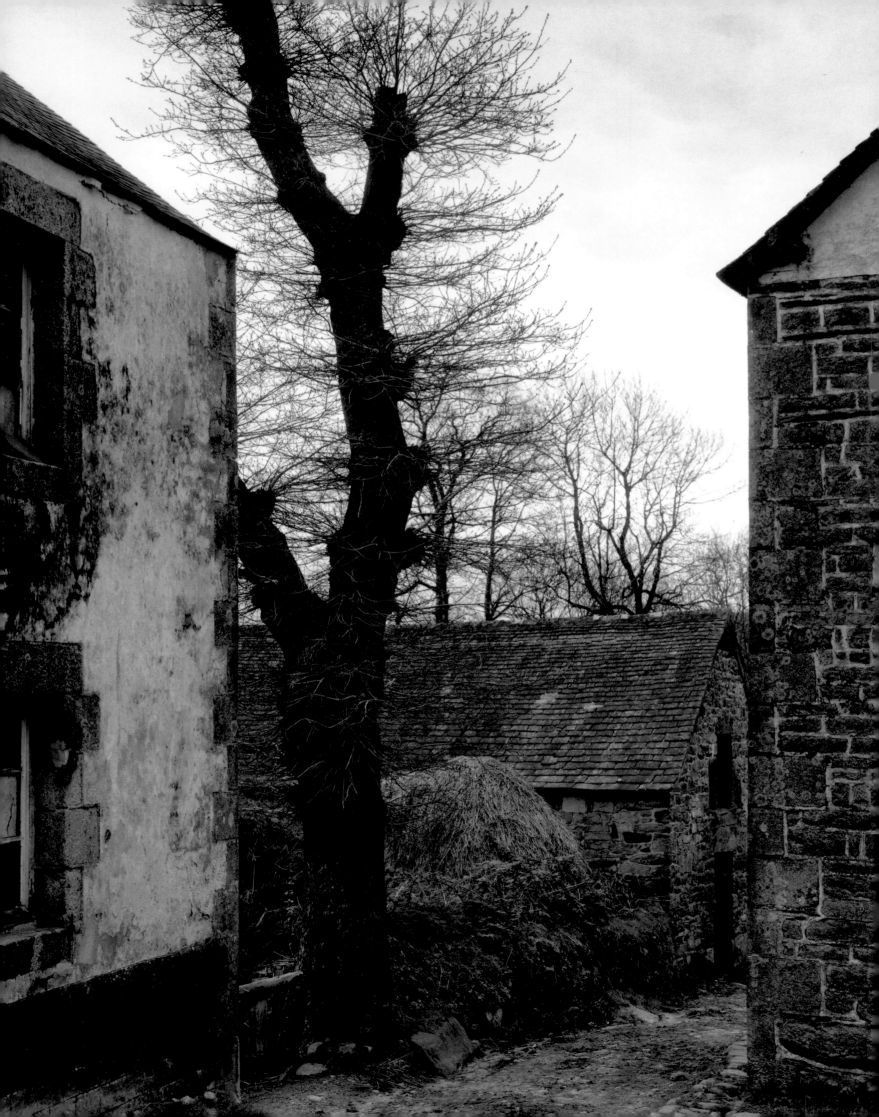

la maison voudrait
devenir un arbre
nourri de la terre
et non pas posé
simplement ici
ici ou bien là
sans savoir pourquoi

The house would like
to become a tree
fed by the earth
instead of being placed
just here
here or there
without knowing why

ses fenêtres-yeux
regardent rêvant
l'oiseau méditant
l'idée de ses branches
arbre qui voudrait
devenir maison
habitée d'humains
et non plus d'oiseaux

her window-eyes
look dreamily at
the young elm and meditate
on the idea of its limbs
the tree that would like
to become a house
inhabited by humans
no longer by birds.

A force d'être là d'enfoncer son entêtement lent dans l'épaisseur du noir
l'arbre finit bientôt par avoir un passé qui sait bien mieux qu'elle même ne pense savoir

Le ciel disait Verlaine est par dessus le toit si bleu si
Mais le ciel de la photo ici est plutôt gris

By virtue of being there,
of growing and pushing
in its slow stubbornness
in the weight of the dark

The tree soon ends up having
a past that knows much more
than it thinks it knows.

The sky,
Verlaine would say,
is above the roof,
so blue,
But the sky
in the photograph here
is rather gray.

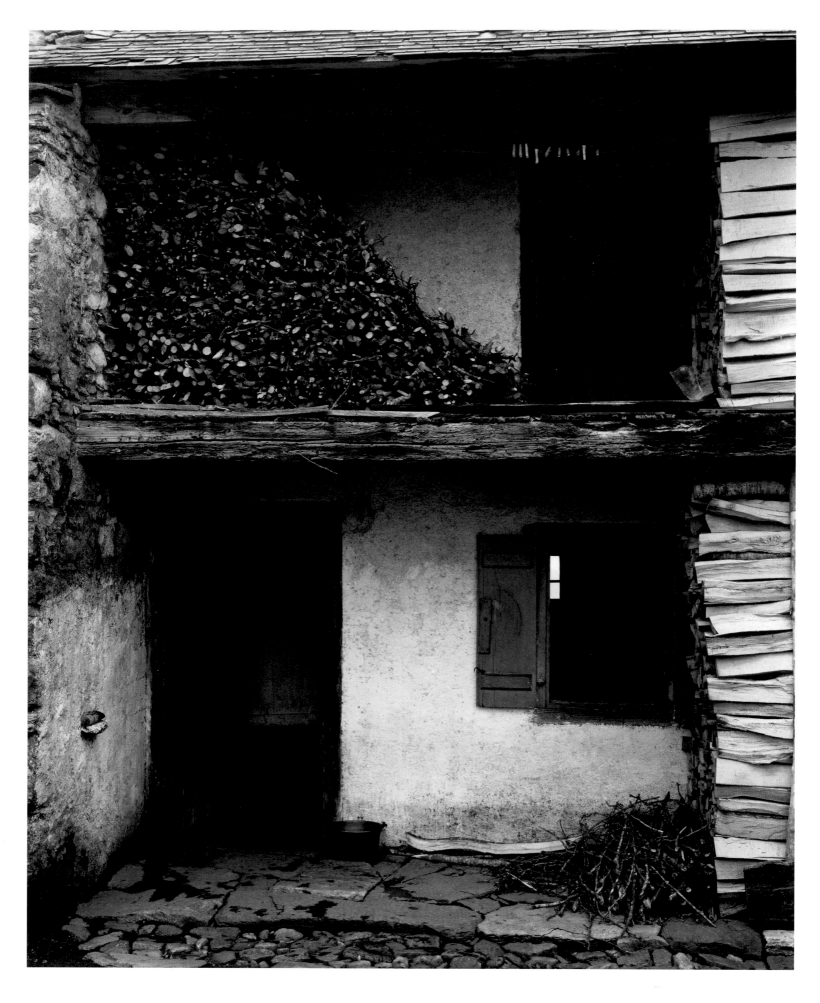

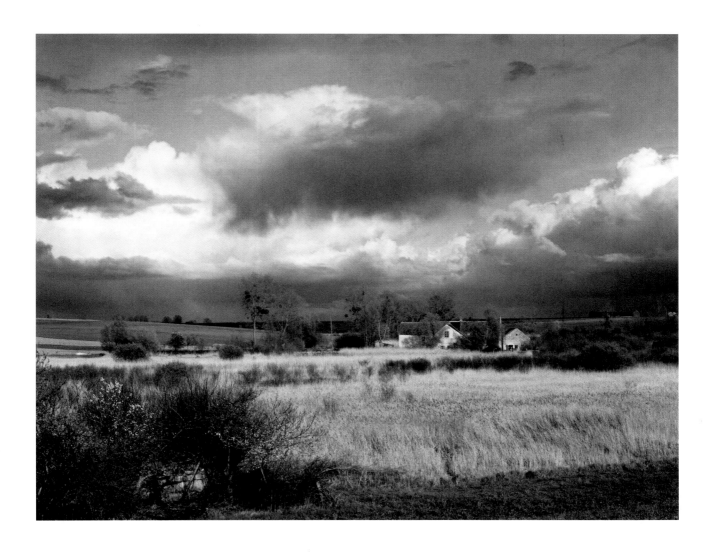

*S*hepherds who sleep in the fields at night see many patterns in the air and on earth that those who sleep in their beds do not see; at a given time they see a comet in the air that looks like a dragon spewing fire from its mouth. Another time it is a white pattern that always appears at night at any hour, which they call the great way of Saint James in Galicia.

Other patterns are like an ascending flaming fire. Still others like a flaming fire going sideways. Another like a small but enduring fire. Others shoot up great flames but do not last very long. Then there are those that are like candelabras, sometimes small, seen both in the air and on earth. Or they see another comet like a burning lance.

Shepherds also see comets in other ways, notably like a burning column as if it were a pillar, but a third of them are comets that last longer than any other. They see five wandering stars that do not move like the others at all and these they call planets, but they are shaped like stars and they are Jupiter, Mars, Venus, and Saturn. And also they see stars of which they call the one bearded, the other hairy, and the other the coveted star.

—THE GREAT CALENDAR AND COMPOST OF SHEPHERDS (TROYES, 1470)

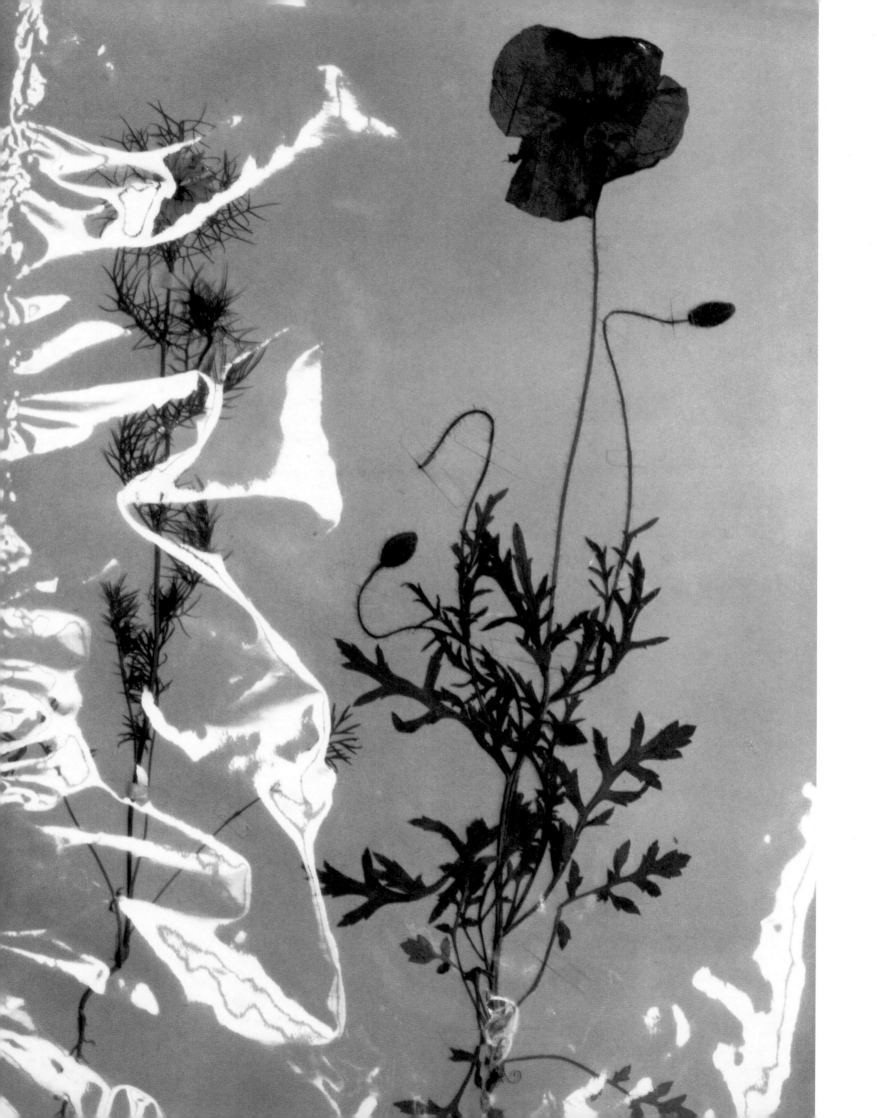

POPPY

The poppy and the cornflower wait for a white cloud to pass so that the tricolor of blue, white, and red will appear in the landscape. The poppy is something one has to watch.

If you don't keep your eye (the good one) open, there it is in whole harvest-choking herds right in the middle of the wheat. With all of its vermilion red, it cries out, very loudly, the word *rooster*, with an echo.

To surmount this, hoeing is not enough. The poppy is swollen with tiny seeds, minuscule, countless, brown. You forget one foot and the following year it all needs to be done again. Better to let the earth rest by planting plants that need to be hoed frequently. Poppies are no friends of broad beans or corn.

This warmly vivacious red, against an orange background, fits gold like a glove. It does well against ripe wheat, even if it is its enemy. In the altarpieces of primitive painters, it bursts out smartly from backgrounds of embossed gold, worked with a bookbinder's punch as on the bindings of books, or completely smooth. But there are poppies everywhere in France.

The poppy has four petals at the end of a long downy stem (a blond down, as on the tanned arms of blond girls who bring in the blond sheaves). In the bud, the four petals are folded tightly like the silk of a parachute. It is hard to believe that so large a flower can be contained in so small a sepal sack. When the sepals fall, the petals come out. They are crumpled like a dress that has just been taken out of a suitcase, but that doesn't last long and then, there they are, without any wrinkles, fresh, well-pressed, brilliant. In the depth of the bud, the ovary is ready to crack open (and, indeed, it will), bursting with seeds, while the stamens try to find shelter where they can.

The base of the petals is stained with black. On the inside, the black spot has a white fringe at the top. Here you can see what beautiful black looks like, it has to be deep and slightly shiny (oily or varnished).

By turning down the petals and tying them in their center with a blade of grass, you can make a lady in stylish dress and crowned with plumes. Superb. You can give her arms by crossing her upper body with a small stick. The lady is ready to go waltzing.

Herbal tea is made by boiling five to ten grams of dry poppy petals in a liter of water. This is a drink to make you fall asleep, make you perspire, and to calm a cough. There is poppy in the mixture they call the herb tea of four flowers (named this way because it is made of six flowers).

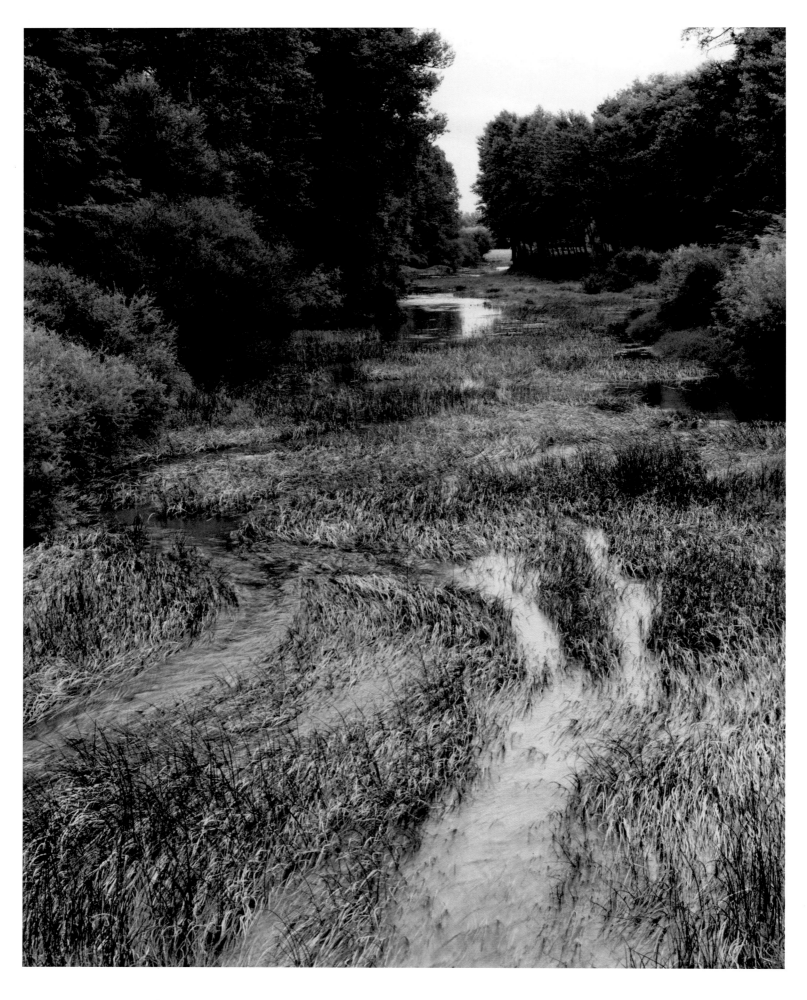

La rivière endormie.

x

Dans son sommeil glissant l'eau se suscite un songe
un chuchotis de joncs de roseaux d'herbes lentes
et ne sait jamais bien dans son dormant mélange
où le règne de l'eau cède au calme des plantes

La rivière engourdie par l'odeur de la menthe
dans les draps de son lit se retourne et se vautre
Mêlant ses mortes eaux à sa chanson coulante
elle est celle qu'elle est surprise d'être une autre

L'eau qui dort se réveille absente de son flot
écarte de ses bras les lianes qui la lient
pour déjouer la verdure et l'incessant complot
qu'ourdissent dans son flux les algues alanguies

The Sleeping River

In its sliding sleep the water creates herself a dream
a whispering of rushes, reeds, and slowly moving grasses
and in her sleeping mixture never quite knows
where the reign of water yields to the tranquillity of plants

Drowsy and dulled by the scent of mint, the river
turns over and sprawls in the sheets of her bed
Mingling the water that's died with the song of what flows
It is the river that's surprised at being another

The water that sleeps wakes away from her course
brushes aside the lianas that bind her
to foil greenery and the incessant plot
that the languid algae weave in her flux.

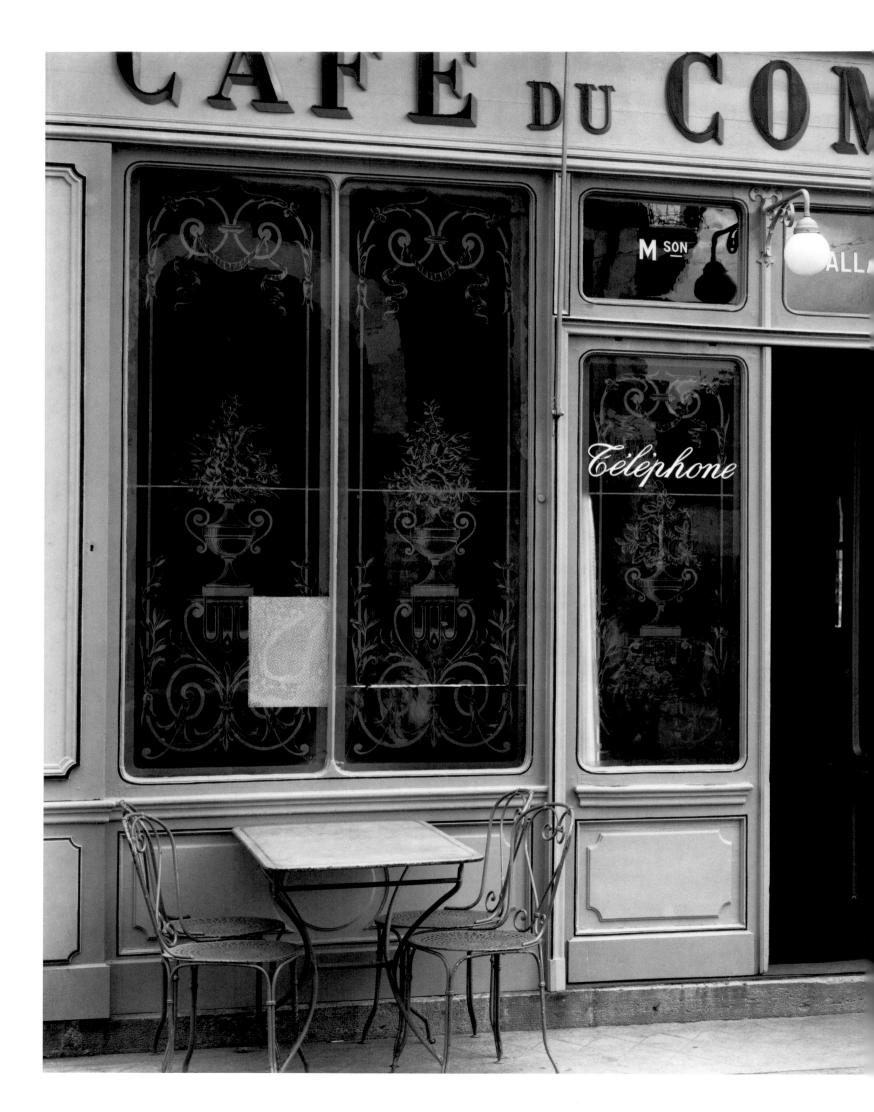

AT THE CAFÉ DU COMMERCE, an altogether different thing (and more) from the commerce of coffee is going on, believe me. Really, it's about ideas, news, and shared feelings. La Bruyère gave the best definition of cafés, which nicely completes Paul Strand's assessment: *"A circle of people linked by conversation and a commerce of the mind."*

Considering that the National Assemblies, the Academies, the Boards of Magistrates and highly placed persons, etc., are nothing but cafés—but cafés where the adhesive of drinks and raised glasses is woefully missing—I am not disdaining these Cafés du Commerce. All sorts of virtues are practiced here, all sorts of pleasures are savored. Only here does downhome politics discover what it is, that is to say, a politics of high level: he who climbs to the top of the steeple sees far. Here alone people no longer define themselves by their positions but by their tastes. "The usual, for Monsieur Carré?" "Yes, the usual:" a glass of white wine (or a Pernod, or a Byrrh). To each his own. That much is agreed. The only thing remaining to be argued is colors. Or to sing one's part well. That's an excellent exercise, singing one's part well in the universal concert. The tables are there, large and small, for people to let themselves go and enjoy the only pure passion that has been granted them: the innocent fondness of being together. I raise my glass to the Café du Commerce, to sociability. I raise my glass to all around, to your good health, to the commerce of people.

I don't know if you are like me, but I think we can very well do without days when something happens, days that war is declared (for example). Please note that something is always happening: (for example) birds. Now there's a bit of news that is really nice to hear, no? *GOOD DAYS. Every day we witness important passages of migrating birds. They herald the summer months. The arrival of the first swallows cannot be far behind.*

With great pleasure we have learned of the black novels of the daily news. GIXXX

Oh, how I prefer the PINK NOTEBOOK . . . *Please note the birth of one little Philippe at the home of Mr. and Mrs. Baillon, postmaster, and one little Gerard at the home of Mr. and Mrs. Camille Commin. We wish the very best for the babies and extend our hearty congratulations to the parents.*

Please note that days without news stories are not less filled with events than others. . . *OUR FIREMEN Firemen were called Friday morning to go to Chasslecq, to the home of M. Bechemilh, mayor of the town, where a chimney fire had broken out. Thanks to their promptness, the disaster, that was beginning to take on enormous proportions, was quickly dealt with.*

Cards: Belotte Competition.— This evening, at 9:00 PM, at the Café Georges, a grand competition of Belotte will be held, with numerous prizes to be won, the first prize being 1,500 francs. Notice to amateurs!

Je ne sais pas si vous êtes comme moi, mais je trouve qu'on se passe très bien des jours où il se passe quelque chose, les jours de déclaration de guerre (par exemple). Remarquez qu'il se passe toujours quelque chose : (par exemple) des oiseaux. Voilà une nouvelle qui fait tout de même plaisir, non ?

LES BEAUX JOURS

Chaque jour, nous assistons à d'importants passages d'oiseaux migrateurs. C'est l'annonce de la belle saison. L'arrivée des premières hirondelles ne saurait tarder.

Aux "Livres Blancs" et aux romans noirs de l'actualité, ah comme je préfère le

CARNET ROSE

Nous avons appris avec plaisir la naissance d'un petit Philippe au foyer de M. et Mme Baillon, receveur des postes, et d'un petit Gérard au foyer de M. et Mme Camille Commin.

Nous adressons nos meilleurs vœux aux bébés et nos cordiales félicitations aux parents.

Remarquez que les jours sans histoires ne sont pas moins chargès d'événements que les autres ...

Concours de belotte. — Ce soir, à 21 heures, café Georges, grand concours de belotte doté de nombreux prix dont 1.500 francs au premier.

CHEZ NOS POMPIERS

Les pompiers ont été alertés, vendredi matin, pour se rendre à Chasslecq, chez M. Bechemilh, maire de cette localité, où un feu de cheminée avait éclaté. Grâce à leur promptitude, le sinistre, qui commençait à prendre des proportions inquiétantes, a été rapidement arrêté.

Avis aux amateurs !

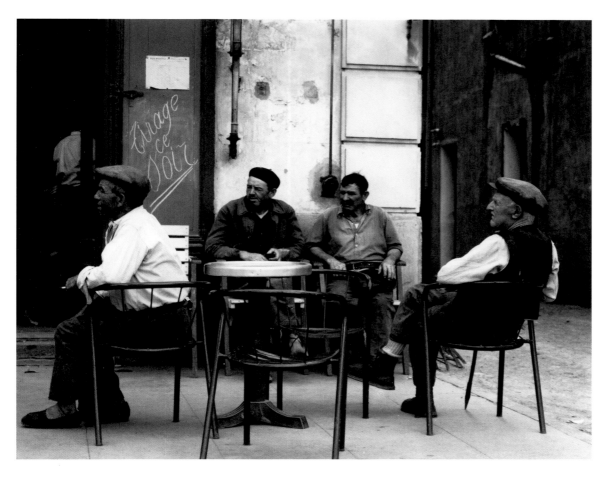

Les langues vont leur train n'écrase pas grand monde,

Pierre SOULES
ne se rendra pas responsable
des dettes que pourrait contracter
son épouse, née Simone FURET.

mais ce train-là je le préfère

aux trains de lois, même quand il s'agit des lois gouvernant nos plaisirs quotidiens. Saviez-vous que

A propos de pêche, d'ailleurs, il y a du tirage sur les lignes. Écoutez :

La pêche au lancer est autorisée dans les mêmes conditions que la pêche à la ligne flottante. ?
Pour exercer ce droit, le pêcheur devra avoir acquitté une taxe dite « du dimanche », qui sera perçue et utilisée suivant les mêmes modalités que la taxe annuelle prévue au paragraphe 1er de l'article 5 de la loi du 15 avril 1829, et fixée au même taux que celle-ci.

~~~~~~~~~~
SOCIETE DE PECHE

Les membres de la Société de pêche La Courcie étaient convoqués en assemblée générale annuelle le dimanche 2 mars, à la mairie.
Le nombre des sociétaires présents étant insuffisant, une autre réunion a été prévue à une date qui n'est pas encore fixée.
Ces abstentions massives sont très regrettables et risquent de décourager les membres du bureau qui, cependant, ont fait preuve d'un dévouement inlassable pour le bien commun des pêcheurs.
N'en déplaise à certains éternels mécontents, la société est et demeure bien vivante, et la modestie des dirigeants dût-elle en souffrir, nous persistons à dire qu'ils font œuvre utile et qu'ils ont droit à beaucoup de félicitations.
~~~~~~~~~~

Oui, on ne stigmatisera jamais assez les "éternels mécontents"

Heureusement les sociétés de beaux-arts marchent mieux que notre société de pêche :

Le Club des mandolinistes d'Angoulême informe ses membres honoraires que les cartes 1952 leur seront présentées incessamment et les prie de bien vouloir les accueillir favorablement.

Y a-t-il une "taxe du dimanche" sur les mandolines ?

Languages go rumbling along, but . . . *Pierre SOULES will not be responsible for the debts incurred by his wife, née Simone FURET.* They don't crush too many folks in their way. I prefer their noise to the rumble of laws, even when it concerns laws dealing with our daily comforts. Did you know that *Fly-fishing is authorized under the same conditions as line fishing. To exercise this right, the fisherman must have paid the "Sunday tax," which is to be collected and used under the same terms as the annual tax described in paragraph I, article 5 of the law of 15 April 1829, and fixed at the same rate later.*

Speaking of fishing, here's a nibble on the line. Listen to this: *FISHING SOCIETY: The members of the fishing society of La Courcie were to gather for an annual meeting on Sunday, March 2 at the Town Hall . As the number of members present was deemed insufficient, another meeting will be held, date to be determined. These large-scale abstentions are very unfortunate, and discouraging to office members who, in the meantime, have shown an unfailing dedication to the common good of fishermen. No thanks to certain perennial malcontents, the society is and will remain active, and though the modesty of its directors may object to our saying this, we insist that they are doing very useful work and deserve much credit and congratulations.* Yes, one can never sufficiently blame the "perennial malcontents."

Fortunately, the fine arts societies are run more smoothly than our fishing society: *The Mandolinists' Club of Angoulême informs its honorary members that the 1952 membership cards will be distributed very shortly, and they should expect to receive them soon.* Is there a "Sunday tax" on mandolins?

It is a day like any other. This:

A FINE GESTURE The gesture is that of the class of 1952, which, at the end of the dance it recently held, handed the sum of 350 francs to the Town Hall, destined for the school cafeteria of Verteuil. Makes up for this:

Violence—On January 12th, at the end of a meeting that took place in Rouillac, an argument brought André Gaschet, 27, and M. Migaud to blows. The former hurled abuses at his adversary, accusing him of having sent the bailiff to his residence because he was not sufficiently insured and had not paid his rent. M. Migaud is Gaschet's landlord. Gaschet, furious, harshly shook M. Migaud and hit him in the face with his fist. Two witnesses have confirmed this in court. The defendant has not denied the charges.

And yet, we have fellow citizens of whom we are very proud, for example *M. Chas. Reible, inspector with the Paris P.T.T. (Postal Services), well-known in Charente, author of a most scholarly study* The Postal Service in Angoumois, *has just received an academic decoration.*

Even in non-tragic times, there are still tragedies that occur, here is the proof: *Having suddenly gone mad in the slaughterhouse, a steer almost caused serious accidents on Wednesday when M. André Arlot, assistant to M. Joyeux, a butcher, succeeded in overpowering and immobilizing the animal. Our compliments go to the man who performed this courageous act.*

If newspapers never had anything else to teach us, how beautiful life would be!

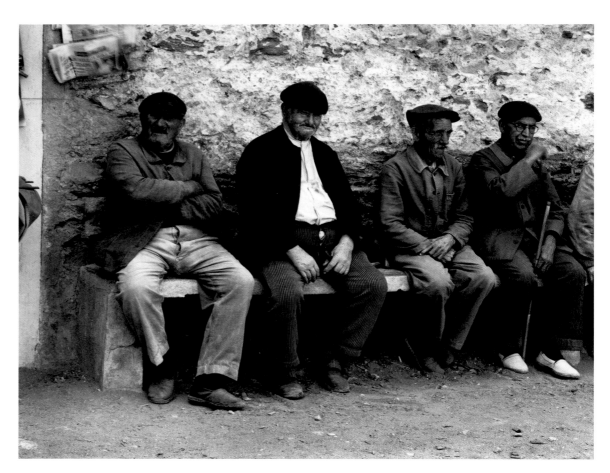

C'est une journée pareille aux autres. Ceci:
nous console de cela:

Et, tout de même, nous avons des concitoyens dont nous sommes très fiers, par exemple

qui

felle à vivre!

UN BEAU GESTE
C'est celui des conscrits de la classe 1952, qui, à l'issue du bal qu'ils ont donné dernièrement, ont remis à la mairie, la somme de 350 francs destinée à la cantine scolaire de Verteuil.

...

Il y a même des tragédies dans les temps pas tragiques, la preuve:

Les violents. — Le 12 janvier, à la sortie d'une réunion, qui avait eu lieu à Rouillac, une discussion a mis aux prises André Gaschet, 27 ans, et M. Migaud. Le premier a invectivé son adversaire lui reprochant d'avoir envoyé à son domicile l'huissier parce qu'il n'était pas suffisamment assuré et n'avait pas payé son loyer. M. Migaud le propriétaire de Gaschet. Ce dernier, très en colère, a sérieusement secoué M. Migaud et l'a frappé d'un coup de poing au visage.
Deux témoins viennent l'affirmer à la barre.
Le prévenu ne conteste pas les faits.

Devenu subitement fou furieux aux abattoirs, un bœuf risquait de provoquer de graves accidents, mercredi, lorsque M. André Arlot, commis chez M. Joyeux, boucher, réussit à le maîtriser et à l'immobiliser. Nos compliments à l'auteur de cet acte de courage.

M. Ch. Reible, inspecteur des P.T.T. à Paris, bien connu en Charente, auteur d'une étude fort savante « la Poste en Angoumois », vient de recevoir les palmes académiques.

Si les journaux n'avaient jamais rien d'autre à nous apprendre, comme la vie serait
Mais, hélas

M. Guy BERTEAU
boulanger à Saint-Clers-Champagne
DEMANDE un APPRENTI
sachant un peu travailler.

A vendre poussette double état neuf, et VOITURE d'ENFANT bon état. S'adr. Café Continental Jonzac (Charente-Maritime)

ELECTION DE NOTRE MISS
C'est le dimanche 24 février courant, en soirée, au cours d'un grand bal animé par le célèbre orchestre Christian, qu'il sera procédé à l'élection de notre Miss et de ses demoiselles d'honneur.
L'heureuse élue sera au nombre des concurrentes pour le titre de Miss Brossac, où toutes les reines du canton seront réunies au cours du bal du 30 mars.

Ottawa, 20 mars. — Rapproché du chiffre de l'année dernière (1 milliard 728 millions de dollars), les crédits militaires demandés pour l'exercice 1952-53 (2 milliards 106 millions) signifient que chaque Canadien devra débourser, cette année, 155 dollars (plus de 60.000 francs) pour la guerre, chiffre sans précédent en temps de paix.

M. Guy BERTEAU, baker in Saint-Clers-Champagne SEEKS an APPRENTICE somewhat familiar with the work. —— For sale: a double stroller new condition and a BABY CARRIAGE in good condition. Contact Cafe Continental Jonzac (Charente-Maritime)

ELECTION OF OUR MISS It will be this Sunday, February 24th, that the election of our Miss and her ladies-in-waiting will take place in the course of a grand dance hosted by the Christian Orchestra. The lucky winner will be among the competitors for the title of Miss Brossac, where all the queens of the canton will be gathered for the dance of March 30th.

But, alas: *Ottawa, March 20th—Comparing last year's figure (1 billion 728 million dollars), the military budget asked for the year 1952–53 (2 billion 108 million) means that every Canadian will have to pay 155 dollars (more than 60,000 francs) this year for warfare, an unprecedented figure in times of peace.*

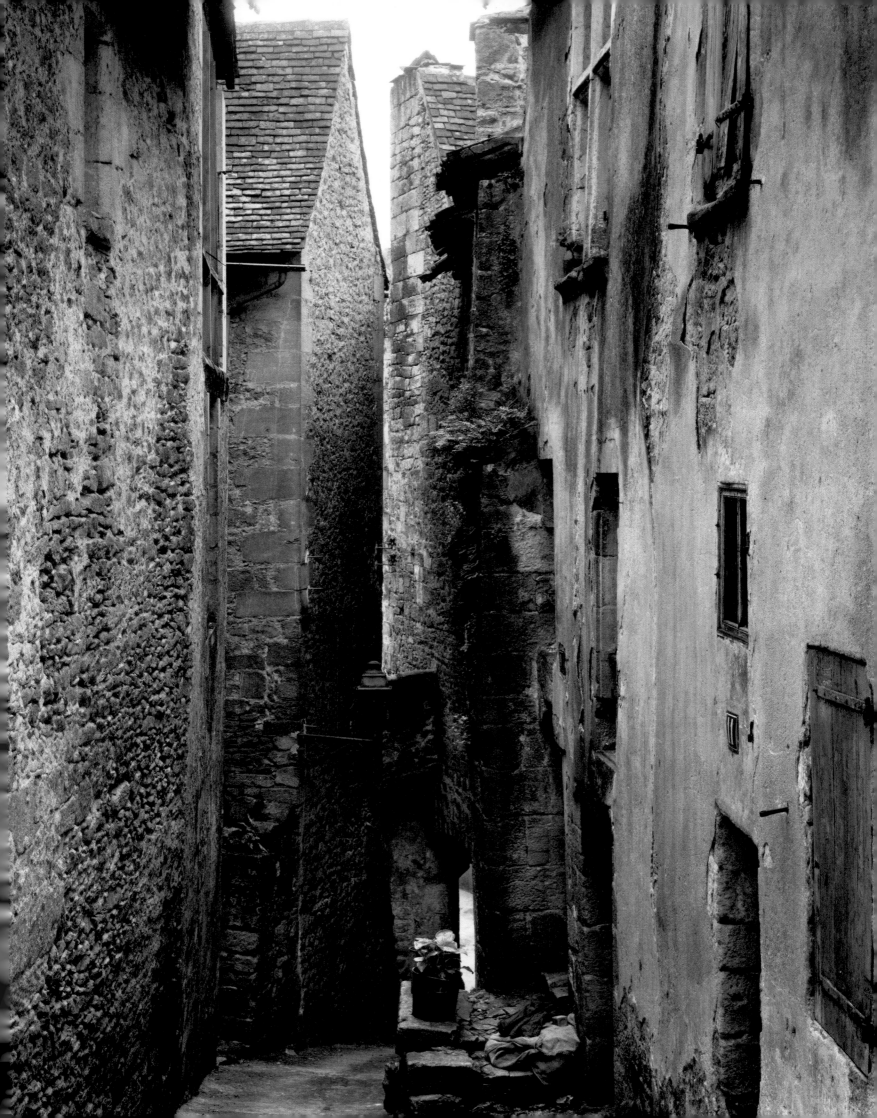

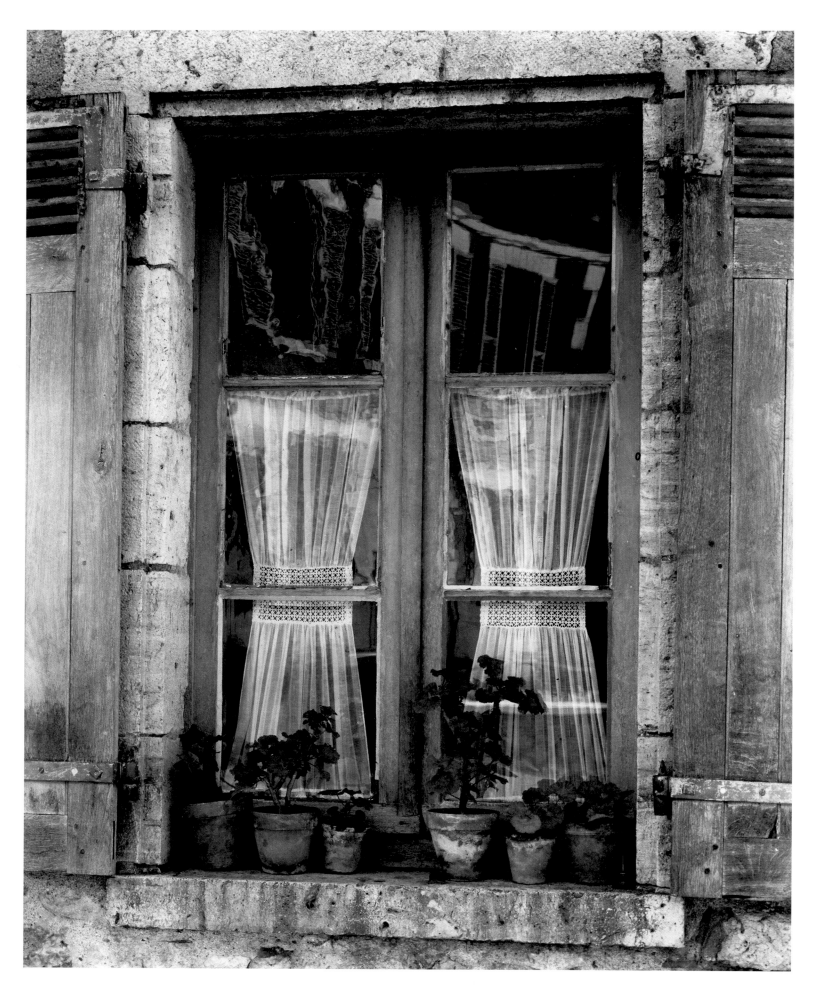

La fenêtre fermée

La fenêtre fermée n'en réfléchit pas moins
le monde qu'elle tient à l'écart d'elle-même
les gens qui n'en finissent jamais de passer
le ciel qui ne sait pas s'arrêter d'être ciel
et la maison d'en face à l'ancre de ses pierres
de son toit de ses murs de son poids de maison

La fenêtre fermée n'est pas si sûre d'elle
ni d'être ce qu'elle est ni de voir ce qui passe
La fenêtre fermée tournée vers son envers
donne à la nuit dedans des nouvelles du jour
et parle à la chaleur du froid qu'il fait dehors

La fenêtre fermée réfléchit lentement
et triste traversée taciturne tapie
rêve de retenir et de garder pour elle
(rien qu'un petit moment préservé de s'enfuir)
ce chat ou cet enfant qui marchent dans la rue
et traversent son eau sans y laisser de trace

The Closed Window

The closed window reflects no less
the world that it holds apart from itself
the people who pass by unendingly
the sky that knows not how to cease
 being sky
and the house across the way anchored
 by its stones by its roof by its walls
of its weight as a house

The closed window is not so sure of itself
neither of being what it is, nor of seeing
 what goes by
The closed window turned the other way
gives the news of the day to the night
 inside
and speaks to the warmth of the cold
 outside

The closed window reflects slowly
and sad traversed the taciturn carpet
dreams of holding and keeping for itself
(nothing more than a small moment
 saved in midair)
this cat or that child walking in the street
and crossing the water without leaving
 a trace

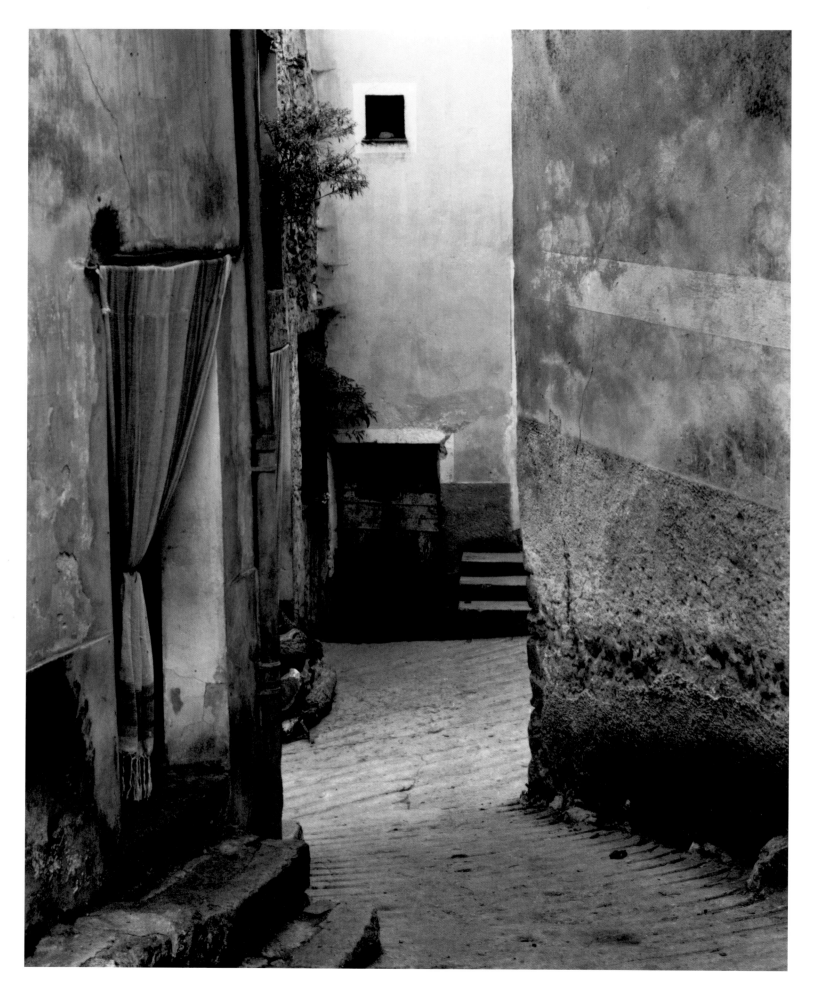

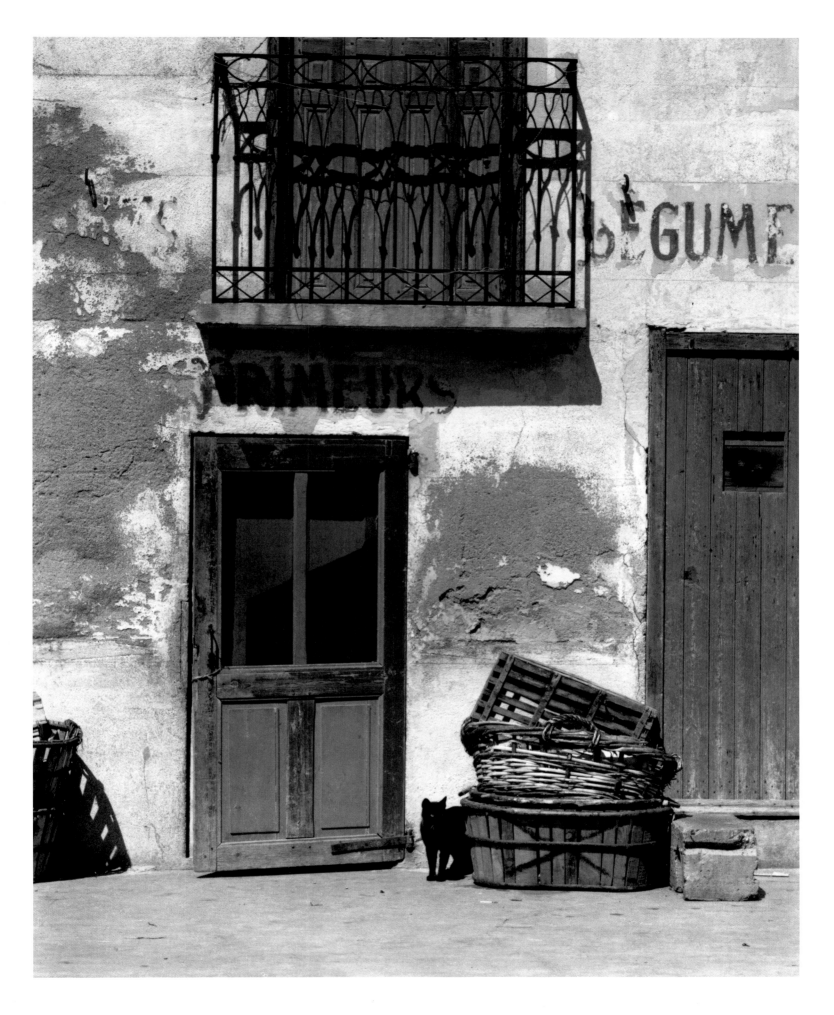

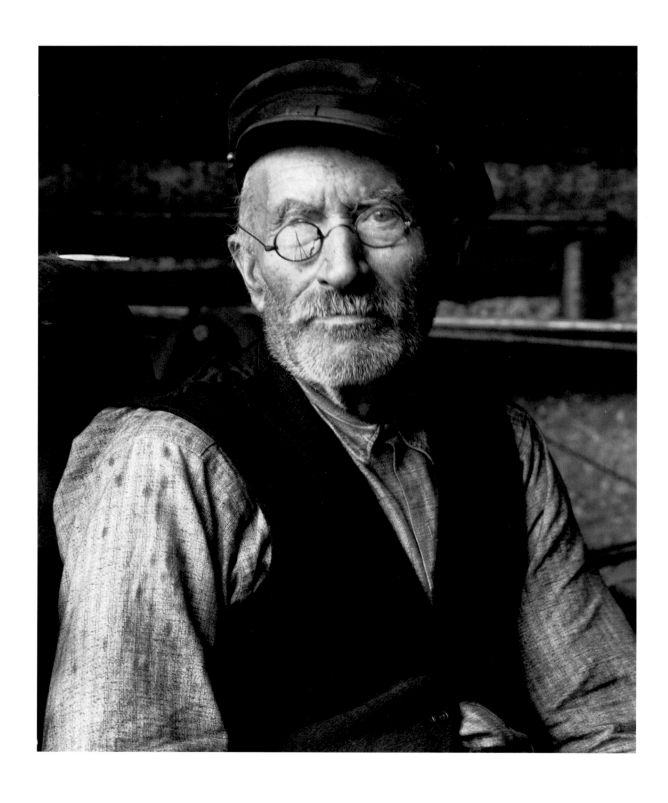

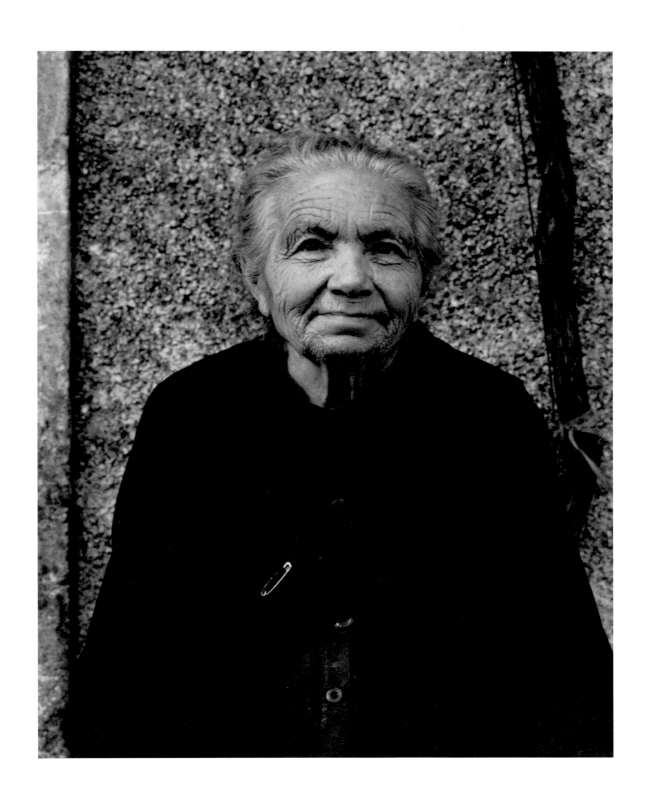

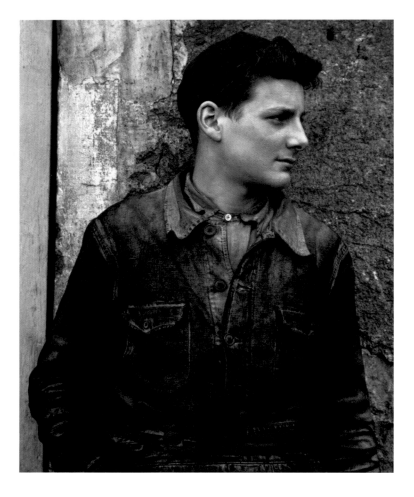
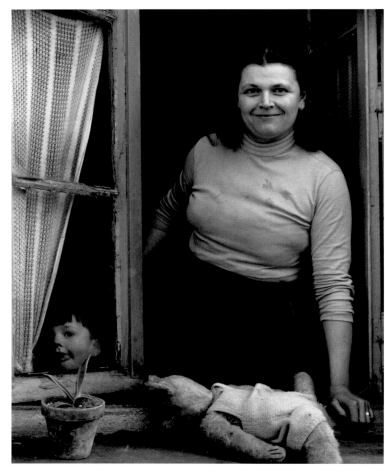
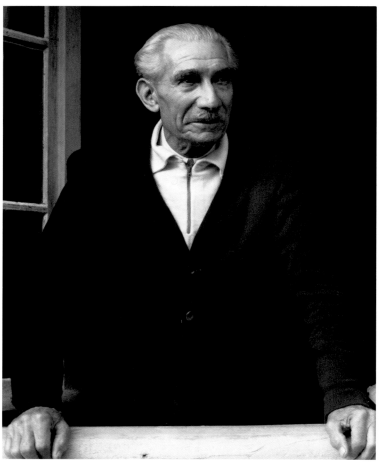
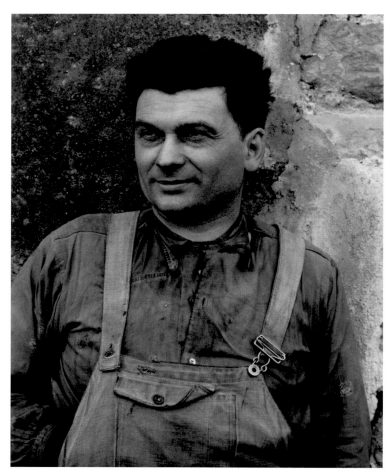

Les gens du pays.

x

Lenormand Chaumeret Lacassaigne Joubert
Pelut Marois Martin Grosjean
Lachaume Legoupil Neuville Roy Bellair
les gens les gens les gens les gens

Les gens et leurs soucis les gens et leurs malheurs
les gens du genre humain
Les gens bien de chez nous les gens plutôt d'ailleurs
tous ces gens en chemin

Je vois des gens d'humeurs variées Des très joyeux
des très furieux des qui s'en moquent
des gagne-gros des gagne-rien des gagne-peu
des qui disent Fichue époque

Jamais les gens ne sont pareils Ni les poètes
Ni la couleur du temps qui passe
Mais en chacun le même espoir brûle et s'entête
Quand aura-t-il fondu la glace ?

People of the Land

Lenormand Chaumeret	People and their worries	I see people in various	People never are alike
Lacassaigne Joubert	people and their misery	moods, some joyful	Neither are poets
Pelut, Marios Martin	people of the human sort	some furious	Nor the color of time passing
Grosjean	People from our parts	some who couldn't care less	But in each the same hope
Lachaume Legoupil Neuville,	people from far away	some who earn a lot,	burns and persists
Roy Bellair	all these people on the move	others nothing, others little	When will it melt the ice?
people people people people		Some who say Rotten times	

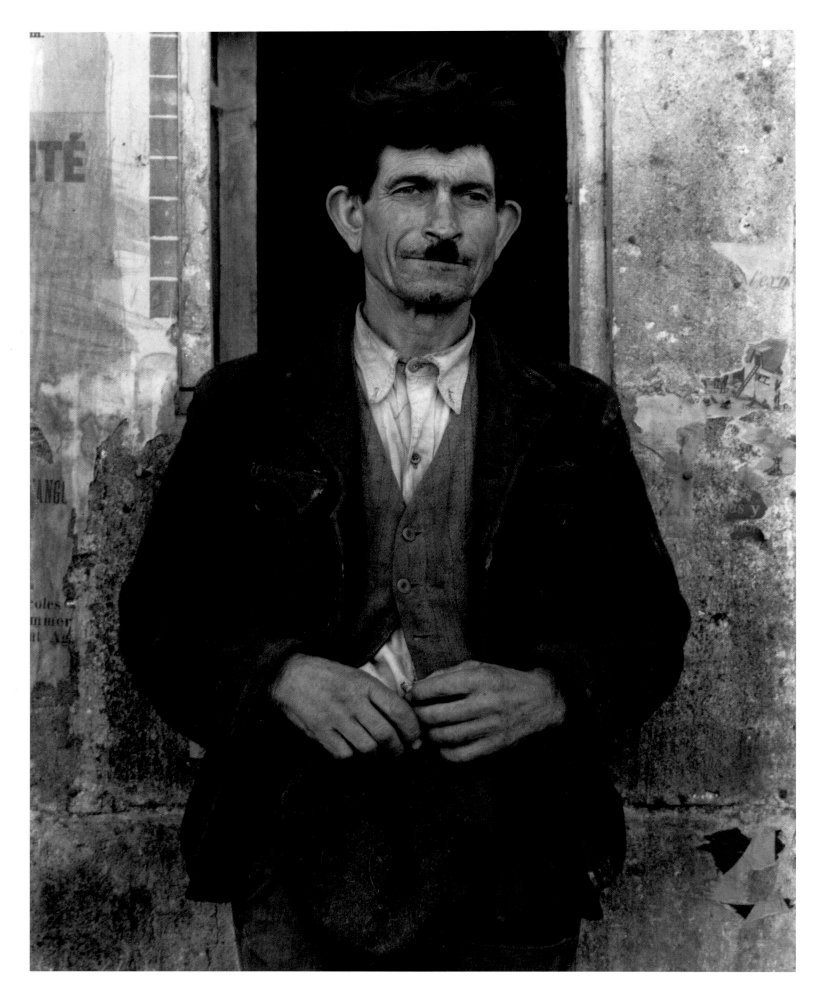

COUNTRY HOME FOR LADIES

by Mme Millet-Robinet
Paris, 1858

Foreword

. . . The lot of workers is improving day by day. The respect shown to their profession would increase even more if they would apply their learning to the improvement of their work and to putting some polish on their reciprocal relationship and the relationship with those who provide them with work. That polish consists of those pleasant and gentle ways that characterize those who have received a good education. Today they could easily obtain every pleasure of a mind that has been enlightened by instruction. The same would be true for farmers, now that agriculture has taken the place that rightfully belongs to it among the schooled and educated classes of society . . .

Chapter II
Ways of guiding and treating domestic servants

One should seek to retain domestic servants as long as possible; to this end, one should hire them when they are young and have them become accustomed to the house so that, in some way, they feel they are at home . . .

. . . It is important to take care that servants do not allow themselves to acquire a taste for make-up and the wild expenses thereby incurred, but one should require them to be clean and well-kept . . .

. . . These attentions are never for naught; servants would really have to be very ungrateful not to respond with constant zeal and true devotion to the benevolence and the solicitude of their masters. It is a mistake to think that the same results would be obtained by raising the salaries of servants. Devotion born of money alone is ephemeral; devotion that comes from the heart is true and lasting . . .

DODINE DE VERT JUS (GRAVY) for river birds, capon or other poultry. In a steel pan put the verjuice underneath the bird to be roasted; take the centers of hard-boiled eggs and half a dozen chicken livers; the livers should be lightly grilled; pass them through a strainer with just the verjuice and add a bit of ginger and chopped parsley; boil this together, and pour over the roast with toasted pieces of bread covering the roast.

GALIMAFRÉE (HASH). Take a leg of lamb freshly cooked and chop it as finely as you can with a plateful of onions. Braise this with a bit of verjuice, some butter, some baking powder, and season with salt.

　　To make another galimafrée, take roasted chicken or capon, cut it into pieces and then fry them in lard or goose fat. Then add either wine or verjuice and for spicing use ginger and salt to taste, then bind with camelina.

LAIT LARDÉ (LARDED MILK). To prepare larded milk, take some milk and boil it on top of the fire; take some eggs and beat them well, add white ginger and beat into your eggs, add some saffron to give the mixture color; take fat lard and cut it into tiny slices, cook it in a pot or a skillet and let it simmer until there is no more liquid; mix it in with the eggs and the milk, salt to taste, and when it has boiled place it in a cloth or a towel, tie it and put as much pressure on it as you can; when it has been pressed for an entire night, the following morning, let it drain out and slice it; when it has been sliced, fry it in lard.

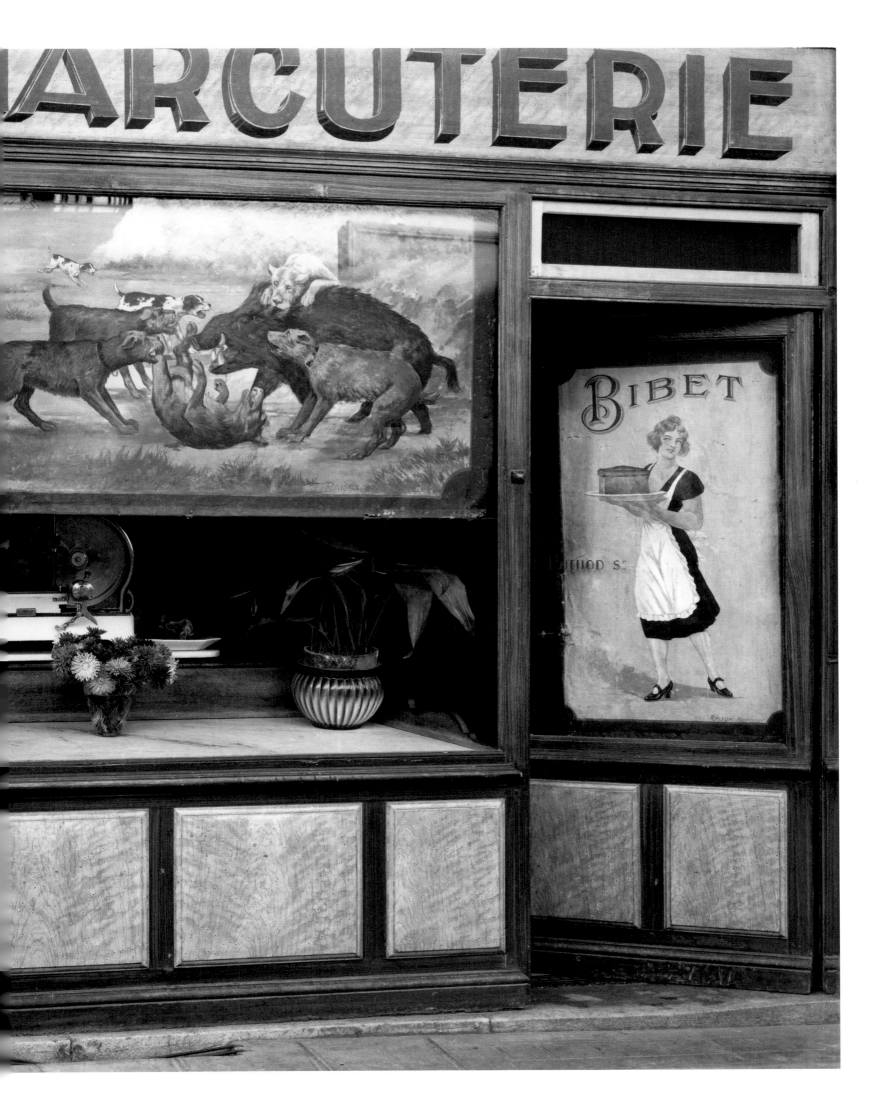

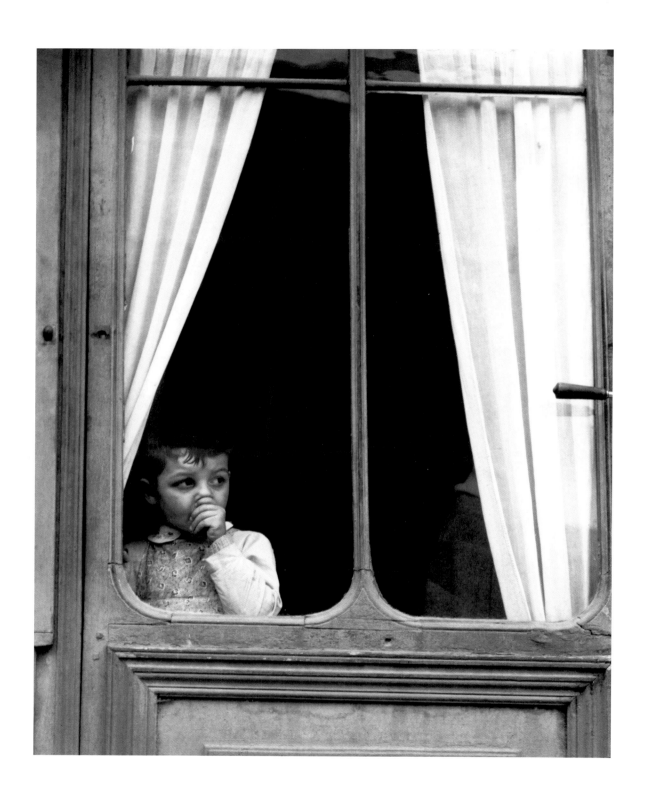

"Oh! I saw, I saw"
"Dear fellow, what did you see?"

"I saw a cow
Dance on the ice
In the heart of summer."
"Dear fellow, you tell lies."

"I saw a partridge
Carrying Paris
In the bottom of a basket."
"Dear fellow, you tell lies."

"I saw a carp
Plucking a harp
On top of a bell tower."
"Dear fellow, you tell lies."

"I saw a wolf
Planting cabbage
In the middle of a meadow."
"Dear fellow, you tell lies."

"I saw a frog
Spinning its distaff
On the edge of a ditch."
"Dear fellow, you tell lies."

"I saw a hare
Trembling with fever
On top of the church."
"Dear fellow, you tell lies."

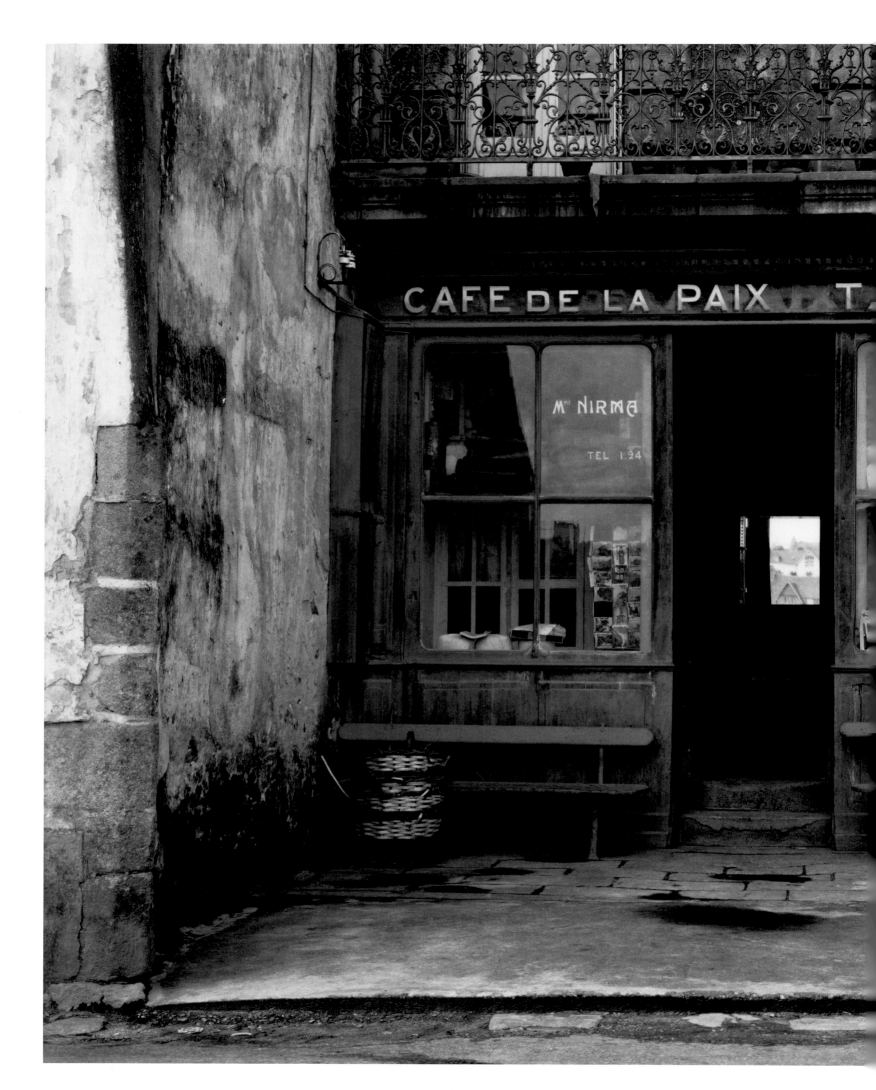

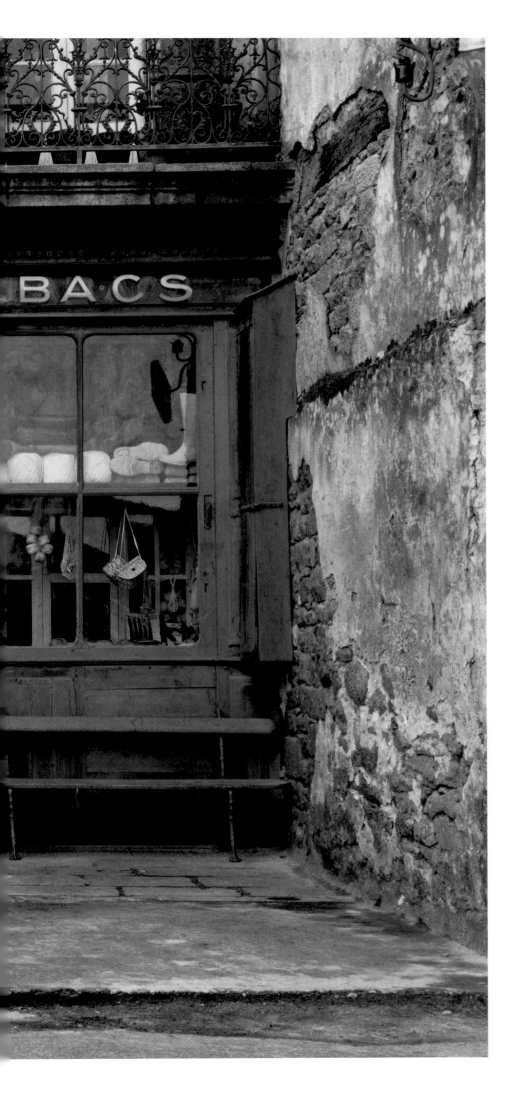

This morning I saw two lines in the newspaper that made me pause: *"The association of war veterans will meet at 8:30 p.m. in the Café de la Paix. Agenda . . ."*

There can be no agenda when the Café de la Paix (the Peace Café) is the meeting place for people who have made war. They have made war—they have made wars. And they did well by it. The war made them (and unmade them).

War has insidious ways of passing unnoticed. It moves forward dressed in colors of wall-gray (shattered walls). It pretends to be a disaster, on the simple level of disasters that nature sends our way: frost, floods, hail, foot-and-mouth disease. It settles into our memories like a reference point on the calendar. The French stumble over dates: that was before the war (I mean the *other* war). . . . I was in Verdun, I tell you I was there . . . Don't worry, you'll be seeing more of them (in war time . . .).

France, a country in which monuments to the dead are used over and over again, from one massacre to the next. They've been granted an extension. Every little bit helps.

Peace fits you like a glove. War fits you like a habit. There are some habits that are worth getting rid of.

When shall we stop learning how to read "Died honorably on the battle field" on the plaque with names?

When will the *Café de la Paix* be willing to say what it means? And when, when will there be peace?

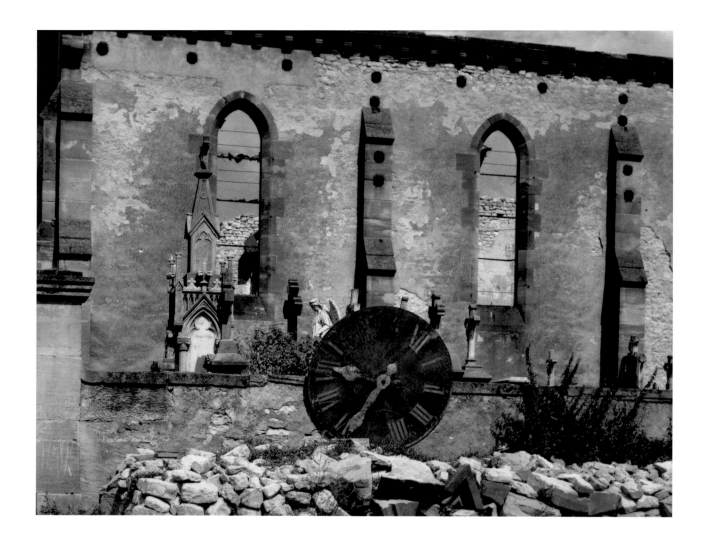

DISAPPEARED MONDAY 27 JUNE

Young man 25 years old, height 1 meter 76, answering to the name LULU MOREL, dressed in blue overalls, yellow-striped blue shirt, distinguishing features: two birth-marks at the base of the skull where the neck begins, has trouble speaking, simple-minded. PLEASE CONTACT HIS FATHER, MR. MOREL IN VILLALÉE (SEINE-ET-OISE).

Mme BEUGNOT seeks her 2 children, Jean-Claude and Suzanne, 4 and 5 years old, blond, blue-eyed, same height, handed over by their maid to a French military convoy, direction Orléans, on the morning of June 15.

Large reward for return of silverware, including arms, furs, clothing, left June 16 near Châteauneuf-sur-Loire, in a gray Peugeot 402. Contact De Noaillat des Graviers, 60 Blvd. Malesherbes.

Mme JOLY, 2 Rue Marie-Benoist (12th arrondissement), seeks news of her husband, Sylvain Joly, 58 years old, left Paris Thursday, June 13, direction Briare, in a Peugeot 301. No. 1468 RJ 5.

M. BOULICAUT, 22 Rue 4-Frères-Peignot, Paris, 15th, seeks news of Jean Boulicaut, 17, and Pierre Richard, 18, last known to be on a 6:00 A.M. train from Beaune-la-Rolande to Bourges, June 15.

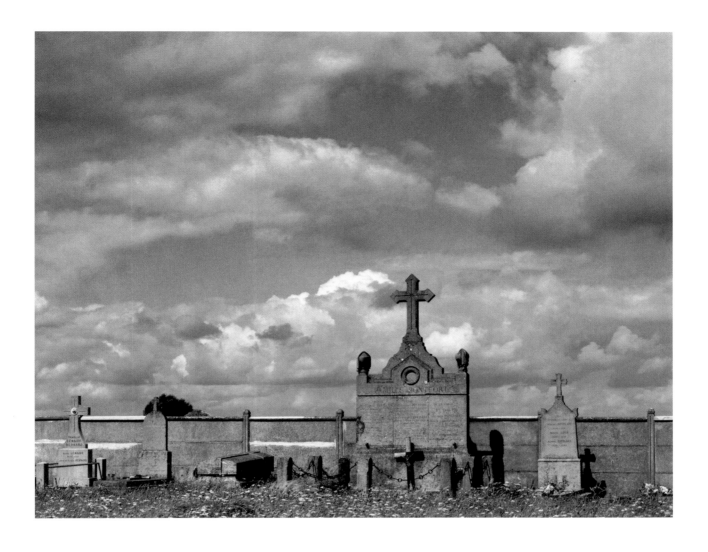

LARGE REWARD for returning big black-and-white cat, responds to the name Charlot, lost during departure between 14 and 16 June. GRIMBERG, 115 Rue du Temple, Paris.

SEEKING package and four suitcases left on truck 407th D.C.A., June 17, Bourges, with laundry, clothing, furs, securities documents, personal papers, insurance policies. Dr. LAZARE, 28 rue d'Avron, Paris. Dr. COPE, 84 Fg. St-Antoine, Paris.—Large reward.

Néré-Poitrault, 23 rue Danton, Courbevoie, looking for husband and son, lost June 17, Route d'Orléans, Bellegarde.

LOST near Moret, June 15, wheelbarrow, 2 suitcases, bag, hatbox, coat, fur, keys. Write Milleret, Gènevilliers, 45 rue de l'Association. Reward.

MME DAVIN, 29 rue de Paris, Joinville-le-Pont, looking for husband Lucien, son André, small daughter Lucienne.

KING RENAUD 1380

King Renaud came back from war
Holding his guts in his hands
His wife upon the battlements stood
To see her King Renaud return.

Quick make me a fine white bed
I shall not lie there very long
And when the midnight clock
 had struck
King Renaud had breathed his last.

Renaud, Renaud, my solace forsooth
There you are now among the Dead.
Earth open up, earth split apart,
That I may see Renaud, my king.

GALLANT KNIGHTS OF FRANCE 1580

"Gallant knights of France
Who are going off to war,
I beg of you, if you please,
To greet my heart's dear friend."

"How should I greet the one
I do not know at all?"
"He is easily recognized,
Dressed as he is in white armor.

He is wearing the white cross
And gilded spurs as well,
And on the end of his lance
A gilded silver blade."

"Oh do not weep, my beauty,
For he has long been dead.
He died out in Brittany,
Slain by Breton men.

I have seen his very grave
On the edge of a meadow green
And I heard his mass be sung
By four Cordeliers."

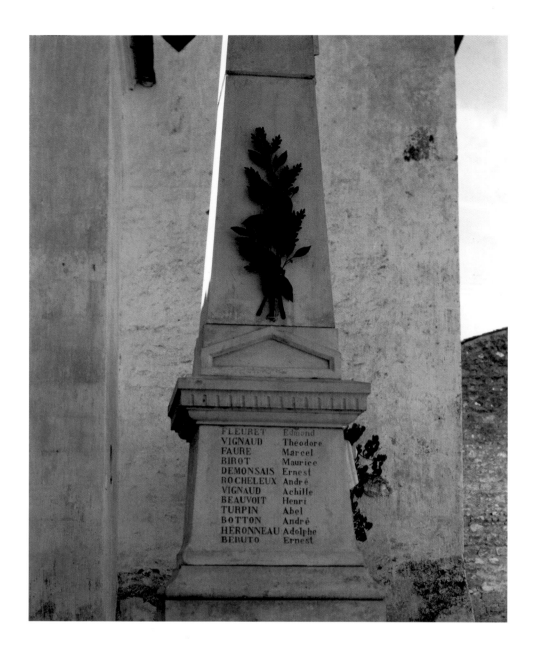

AWAKE, YOU FOLKS OF PICARDY 1480

Awake, you folks of Picardy and Burgundy as well,
And find a way to bring and bear some solid sticks,
For here the spring has come again and that's the season too
Of going off to wage a war, deliver many blows.

So speaks the one who doesn't know what warfare really is;
I swear to you, upon my soul, it's a most pitiable fact,
That many a man of arms, sweet and kind companions
Not only gown and hood have lost, but also lost their lives.

SONG OF CRAONNE 1917

I

When at the end of a single week
Rest time has gone by
We'll occupy the trenches again,
Our life made highly useful,
For without us they'll be mauled.
Yes, but right this very moment
We are drained and worn,
The men can march no longer,
Their hearts are so despondent
With their sobs and with their tears
We bid a farewell to our citizenry.
Even without drums,
Without trumpets, too, we go off out there
 lowering our heads!

II

A whole week of trenches,
A whole week of distress,
Still we are hopeful.
At last the relief team
We wait without letup.
When with night falling
In the deepest of silence
We see someone come forward
An officer of light infantrymen
They've come to replace us . . .
Softly, in the darkness,
Below the falling night,
Our infantrymen come
 looking for their tomb.

REFRAIN

Farewell to life, farewell to love,
Farewell to all our women,
It's not over yet, goes on and on,
This repulsive awful war.
It's in Craonne, on the plateau,
That we must leave our skins behind
For all of us we are condemned,
We are the sacrificial lambs . . .

III

It's miserable to have to see
So many rich men live it up
On all the fine wide avenues.
If for them life is quite rosy,
For us it's rather a different tale.
Instead of sauntering around
All those well-off gentlemen
Would do better to join the trenches,
Where all our comrades
Spread out far and wide
To save the effects of those gentlemen.

REFRAIN

Farewell to life, farewell to love,
Farewell to all our women,
It's not over yet, goes on and on,
This repulsive awful war.
It's your turn now, fat gentlemen,
To climb high up on the plateau.
If you want to wage a war so much,
Pay for it then with your own hide.

MORTS AU CHAMP D'HONNEUR

MÉD. MILITAIRE _ CR DE GUERRE

BEURG Maurice
20 ans _ Soldat 12e Dragons
Mort à PASSY en VALOIS
le 2 Juin 1918

MÉD. MILITAIRE _ CR DE GUERRE

GAMBIER Louis
24 ans _ Adj. 50e Infanterie
Mort à FRAY
le 19 Sept. 1914

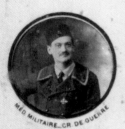

MÉD. MILITAIRE _ CR DE GUERRE

TRICHARD Marcel
22 ans _ Serg 3e Inf. Col.
Mort à RAVIGNY
le 1er Nov. 1918

MÉD. MILITAIRE _ CR DE GUERRE

BOISSEAU Fernand
21 ans _ Soldat 158e Infanterie
Mort à THIONVILLE
le 24 Août 1914

MÉD. MILITAIRE _ CR DE GUERRE

BRUMEAU Jean
31 ans _ Capor.107e Infanterie
Mort en ALSACE
le 28 Mai 1915

FORT Armand
26 ans _ Soldat 15e Infirmier
Mort sur le SOUTAY
le 16 Avril 1917

Commune de GONDEVILLE

I believe in the courage of our soldiers, in the knowledge and the devotion of our leaders, I believe in the strength of right, in the crusade of the civilized, in eternal, imperishable, and much-needed France. I believe in the price of sorrow and in the merit of hope, I believe in the blood of the wound and in the holy water of the font, in artillery fire and the flame of the candle, in the beads of the rosary, I believe in the sacred wishes of old men and in the all-powerful ignorance of children . . . I believe in the prayer of women, in the heroic insomnia of wives, in the pious calm of mothers, in the purity of our cause, in the immaculate glory of our flags, I believe in hands armed with steel and I believe in hands joined. I believe in us, I believe in God. I believe, I believe.

HENRI LAVEDAN,
OF THE ACADÉMIE FRANÇAISE
(*Illustration*, 1915)

A s many as you wish, all the way to the left! As long as there is a single one left! As long as there is a single living person, the living and the dead all at the same time! As many as you wish, General!

PAUL CLAUDEL,
OF THE ACADÉMIE FRANÇAISE

I was at the July 14th parade and I wept a great deal. I love soldiers very much, especially those who still look like flowers.

LOUISE DE VILMORIN

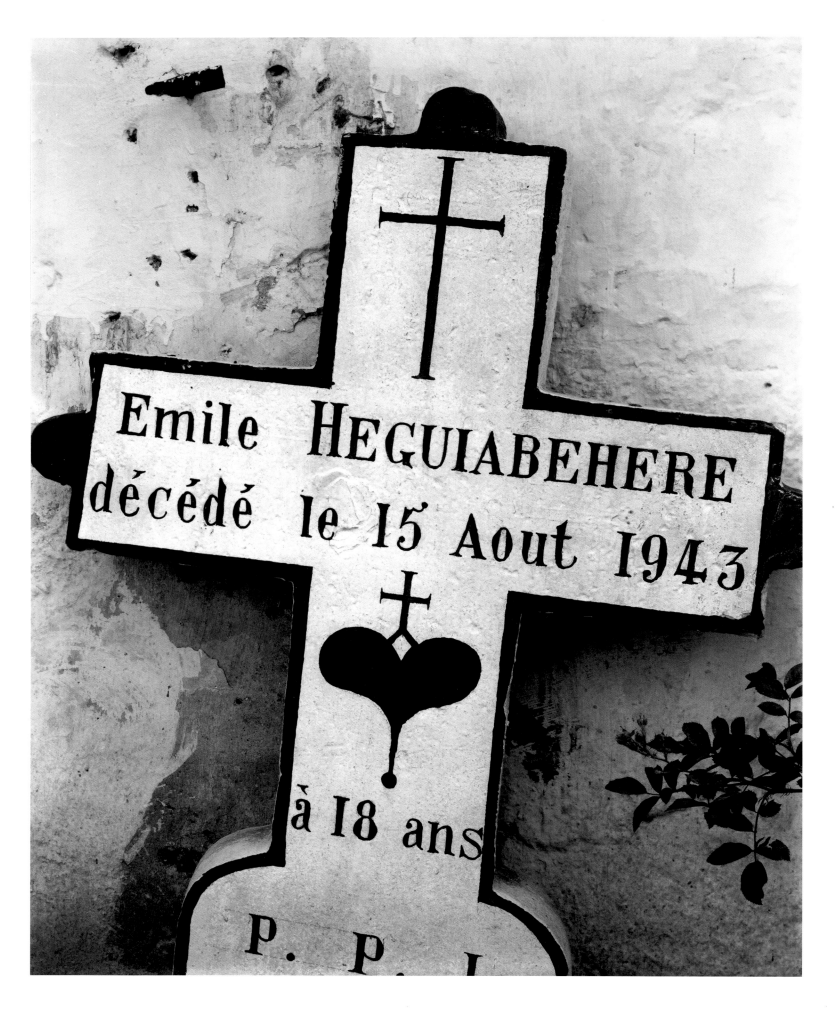

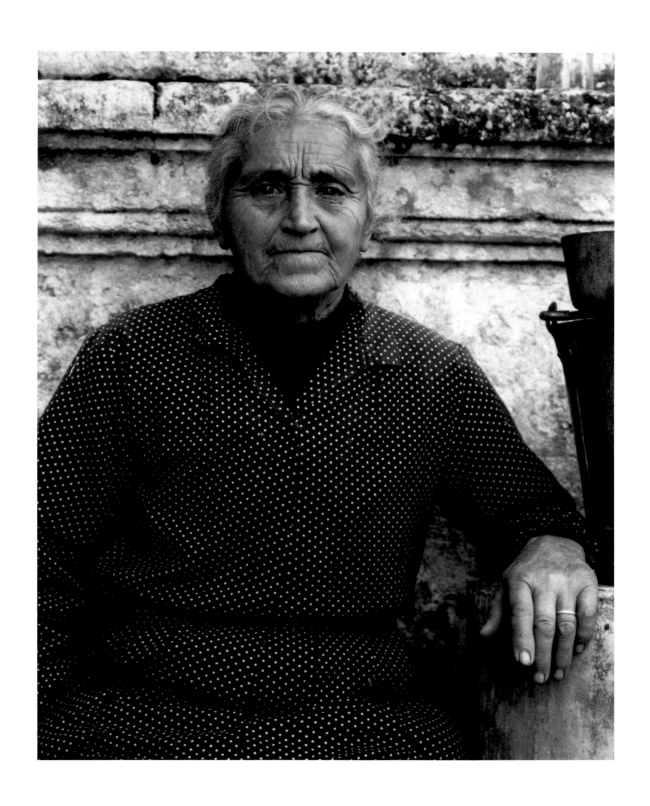

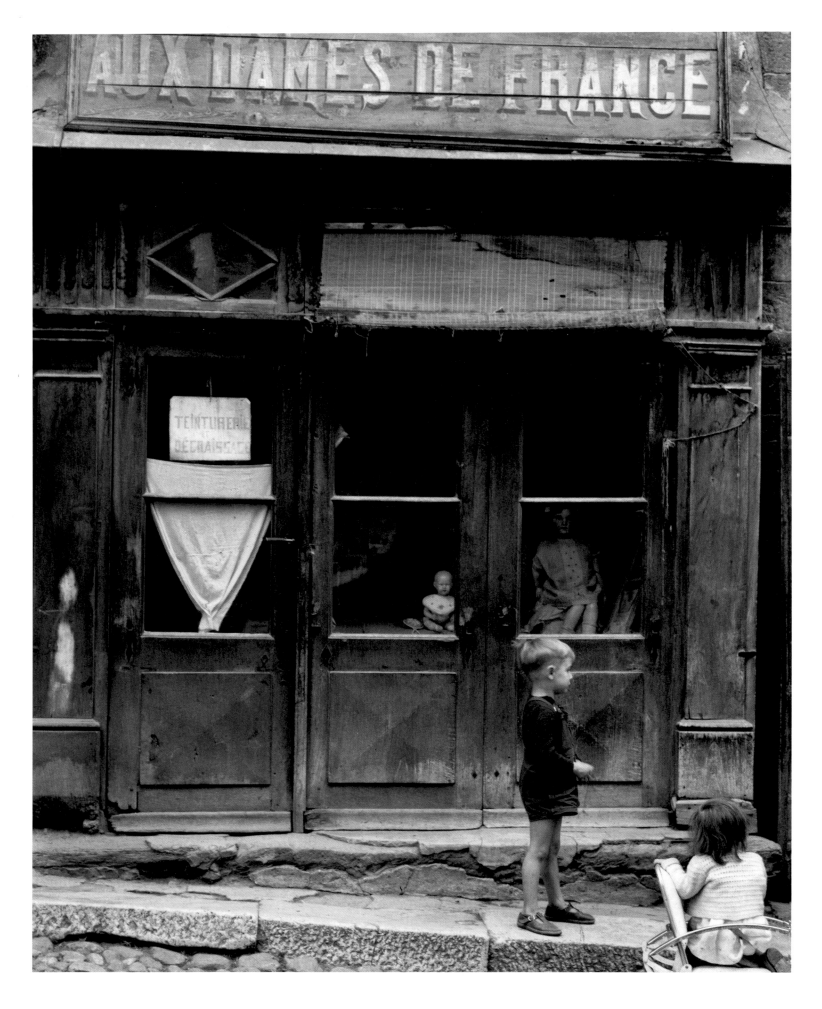

The ladies of France are ladies of days gone by, they are ladies of the snows of yesteryear. Once the ladies of France used to be fairies, now they are housewives; they used to be fairies of the forest, they have retired, they are fairies of the home. The ladies of France remember. Sad house, sad ladies . . .

Sometimes it happens that France, my country, frightens me. The lady of France today is a Sleeping Beauty. Has France fallen asleep, has France been paid off, has France slowed down? Sweet and somewhat crazy France, that used to build such immodest palaces and such unmeasurable cathedrals on its so modest hillsides, France with her fresh cheeks, her lively ideas, her beating heart, in your villages I seek in vain the face that I once learned to know. —The baker's wife has no more money, and reason has no more virtues. —France is sleeping a slow death. —She is living in the olden days. She is so poor and so badly dressed, has such a gray look and such sad streets, my France that used to laugh and decorate her walls with flags. Wake up, Sleeping Beauty, wake up and come back to life. I am sad for my country, for the little boy, for his little sister, for whom the ladies of France are neither Mélusine, nor Joan of Arc—the Maiden of Lorraine—, nor Danièle de Corse, nor any one of those light-eyed beauties, but merely the poverty photographed by Paul Strand, this all too-familiar poverty, so everyday that we hardly even pay attention to it any longer.

The ladies of France, are they ladies of olden days, of days gone by, of an already legendary history—and of snows so distant, so long ago?

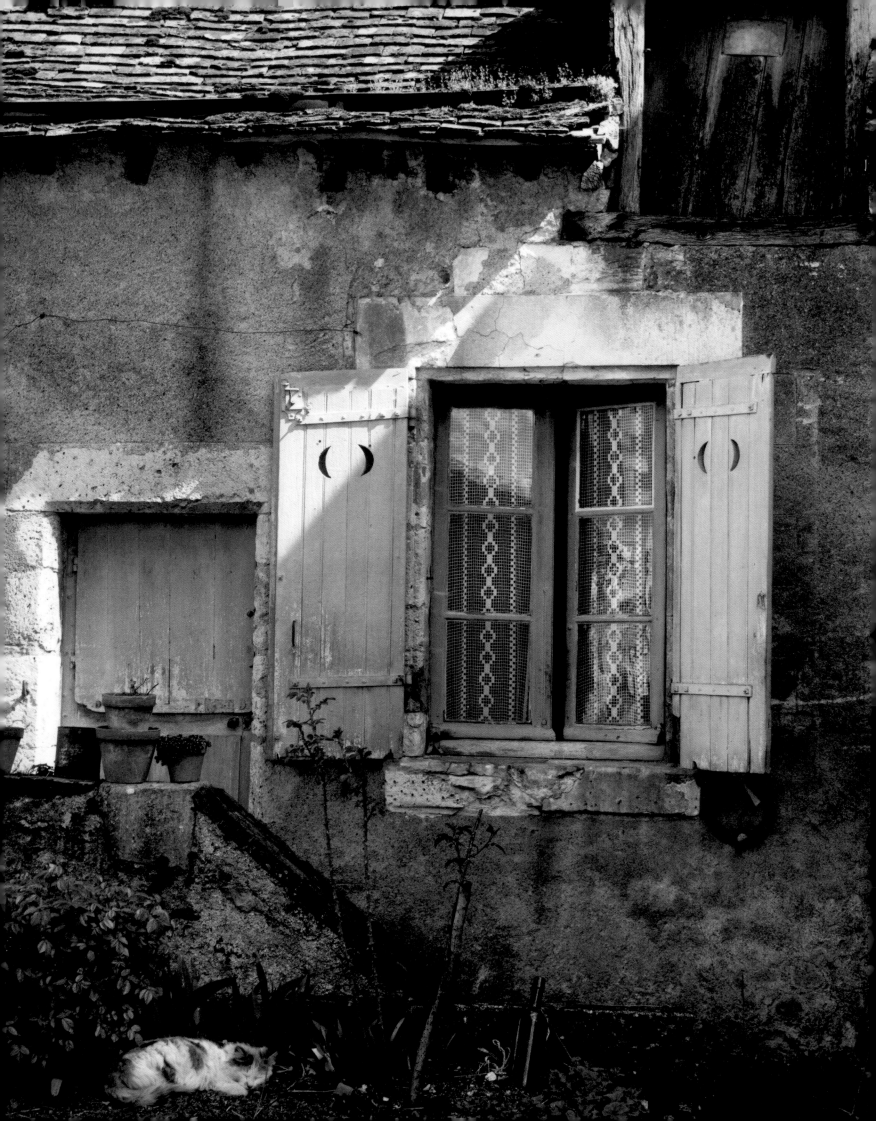

It seems that one bird in the hand is better than two in the bush. It seems that there is no place like home. It seems that the happiest man is he who wants the least. It seems that mediocrity is happiness when it belongs to the species of gilded mediocrity (in Latin *aurea mediocritas*). It seems that the word *small* is the key word of France, my country: small villages (like ours), small landowners (attached to the soil like a dog to his doghouse), small soldiers (little grunts), the person living on a small investment (dying a slow death), small Liré (rather my small Liré than the Palatine Mountain), little old ladies (who aren't old and crotchety), small savings (the woolen sock will yet save France), small worries, small ideas, small joys and small-common people.

It seems that one should let sleeping cats lie.
It seems . . .

Well then, what seems is not of interest to me. If you really think I'm going to be deeply touched facing this door, this pot of flowers, these curtains, these steps, facing these green shutters and the cat asleep in the sun, if you really think I'm going to start purring in unison with this silence, this peace, the bottle in the corner with the flowers, ha, think again! For I know all too well what's hiding behind this serenity, these sedate curtains, the closed door, the sleeping cat, and the sun that slips one finger in to see what wood is used to make the heat. I know these too long days too well, the life where ends never quite meet, the work from dawn to dark night, the housewife and her husband, the day laborer (and if they're not at home it's because they're working), the bread soup and the hard bed, the son who died in the war, and the one who works for the railroads, and everything that could be the stuff of cheap poetry, for novelists or the ballad-singers, but—excuse me—I won't go along with it, I'm not playing. Poverty that doesn't look like poverty is still poverty.

Ah, let's wake up the sleeping cat!

SAYINGS ON FRENCH SUNDIALS

Cherish the light.
(Witry-lès-Reims)

Live free or die.
(Les Noyers, community of Nouâtre, Indre-et-Loire)

Life like shade passes in but a few hours.
(Delut, near Montmédy, Meuse)

Bad or good, I mark the time.
Good for him who laughs, bad for him who weeps.
(Palavas, Hérault)

Work has no limits.
(Le Plan-de-Moissac, Var)

I await the time.
(Cité de Carcassonne)

Time flies.
(Val-de-la-Haye, Seine-Inférieure)

As you watch me you grow older.
(Loches, Indre-et-Loire)

Passer-by, hurry, handsome one,
Don't be like my hand,
That settles and no longer moves
Except with the sun's help.
(Tourettes-sur-Loup, Alpes-Maritimes)

I run without feet, I speak without a tongue.
(Saint-Marcellin, Isère)

Shade passes by and passes by again,
But man passes by and does not return.
(Magagnosc, Alpes-Maritimes)

Placing yourself in front of the sun does not prevent it from moving.
(Bourganeuf, Indre)

May night take me to where my love resides.
(Marancheville, Charente)

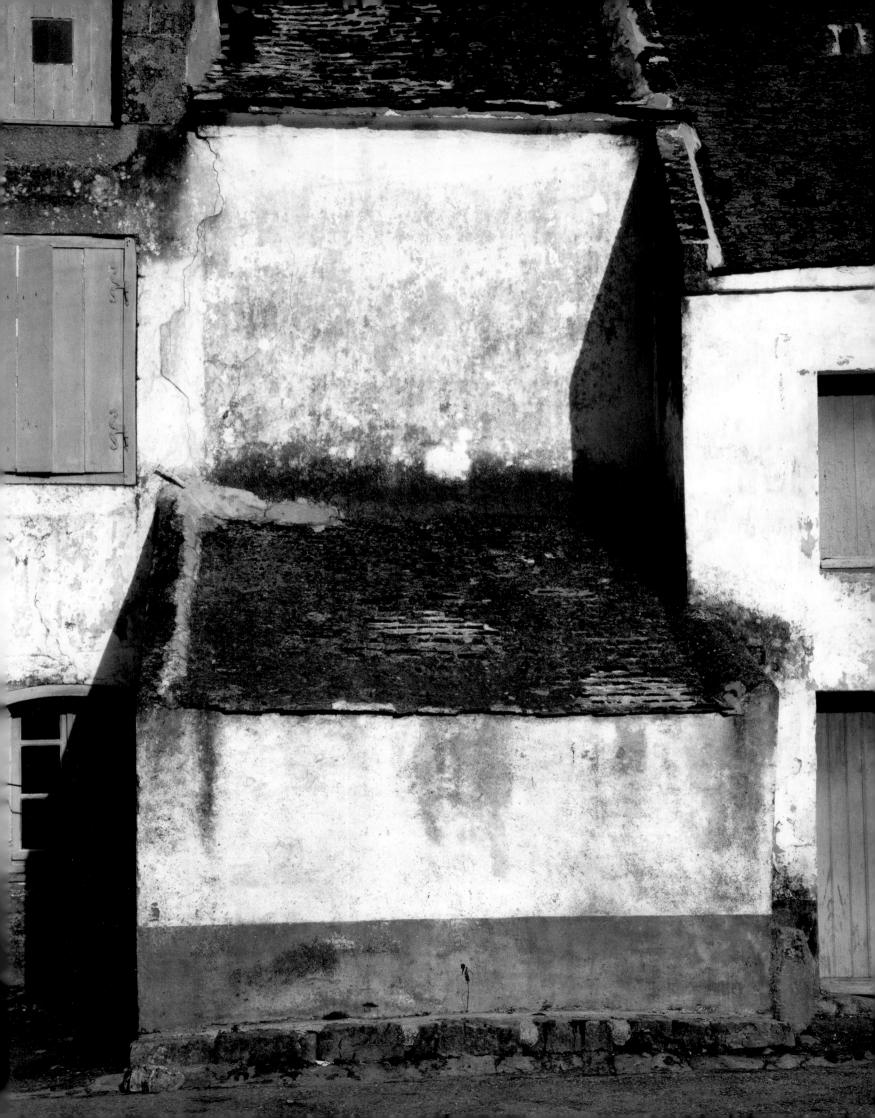

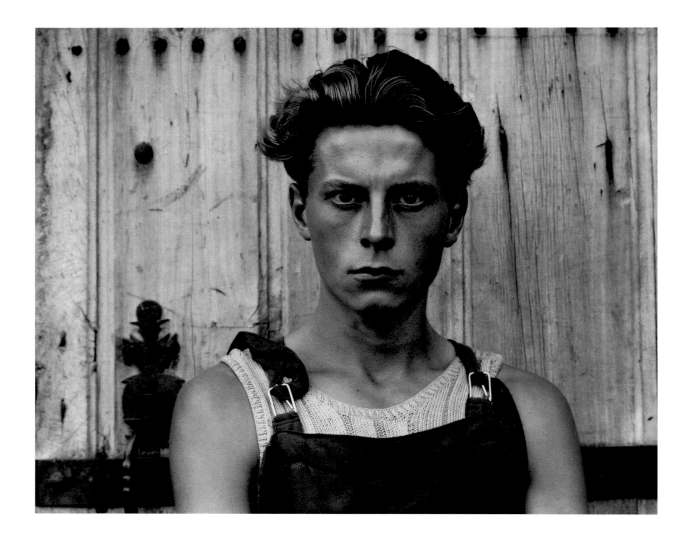

But when France gets angry it's for real. When France gets angry, the world begins to move. It is for everyone that she gets to work, takes her woodcutter's axe, begins to cut down the dead wood, cut off the heads of kings, the fettering underbrush. For a whole century, it was not necessary to speak of the French Revolution, it sufficed to say "the Revolution," and everyone knew what was meant. It was not just about Paris and France. It was about all of Europe. The French were simply the first ones in the class. They had gotten into the habit of being the eldest Sons of the Church and they continued by being the eldest Sons of Justice.

Would France sleep the sleep of the injust? Are we the dreamers of a tired country, of a homeland sitting by the side of the road, sluggish and abandoned, watching the others pass by without saying a word? Will it be as sad to be born French in the middle of this century as it was to be born Chinese in 1850?

No, I don't think so. The look from one of our boys is enough for me to feel that the French still know how to roll up their sleeves and march down new roads with big strides. No, we shall not remain as the slaves of Europe. Our people are resourceful.

We think that it is disgruntledness that causes revolutions. That is true, in a sense that's right. But revolutions are not caused so much by people who are angry as by people who celebrate being done with what made them angry. Revolutions are times of great joy, a joy that suddenly goes to the head and the heart of a people. Nothing resembles a celebration more than a successful revolution. It is the long vacation that mankind grants to its anxiety. A revolution is a serious thing, but it is a joyfully serious thing. It is a dénouement, in which the knots are loosened for the casting off. Revolutions in France are made victorious with laughter and jubilation as much as with blood and gunpowder and bullets. A revolution is the pleasure of stretching, of (finally) taking it easy, of feeling that there's plenty of room, of laughing about being done with it and the fun of a new start; it is Gavroche sitting down on the king's throne, it is an entire country feeling its hull trembling as it glides through stagnant waters, casting off, taking to the wide open sea, drifting freely. A revolution is not an arrival, an end. It is a departure, a glow, a wind of happiness. It is a nation that feels sunlight in its eyes.

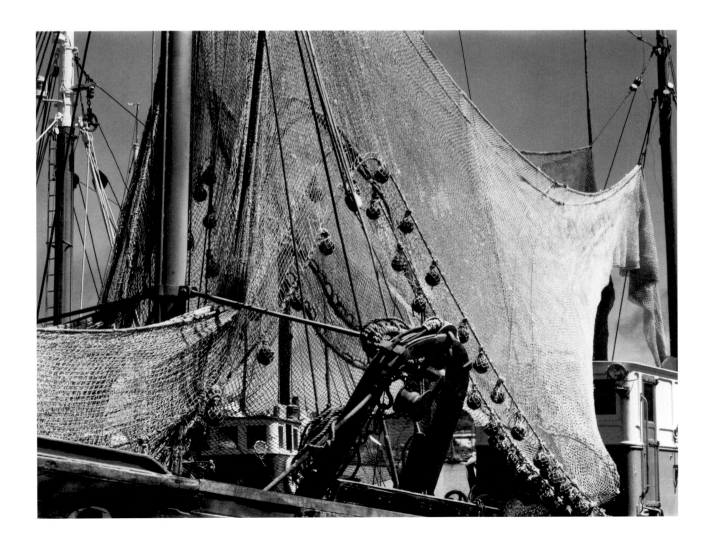

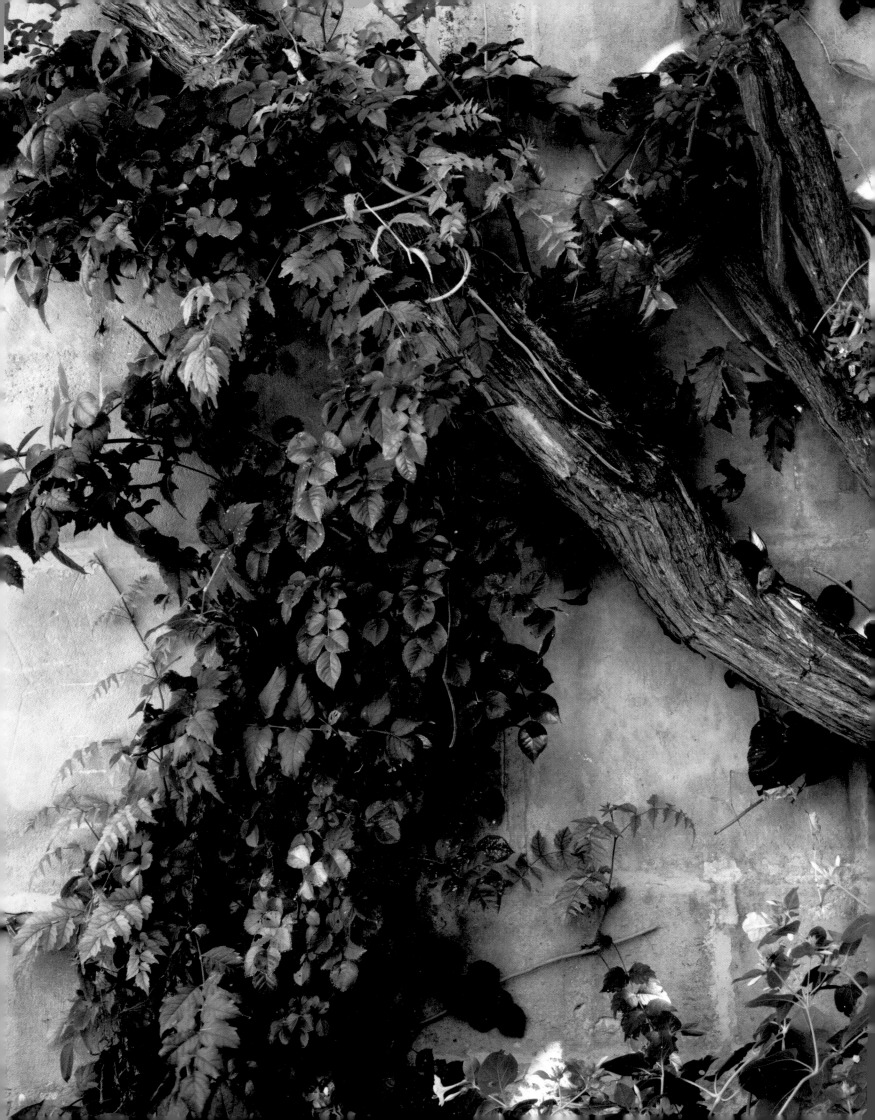

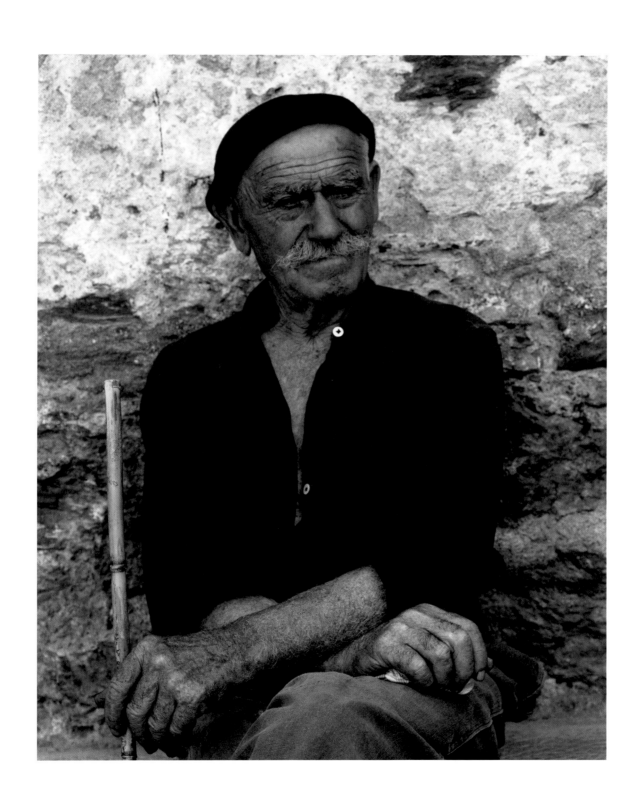

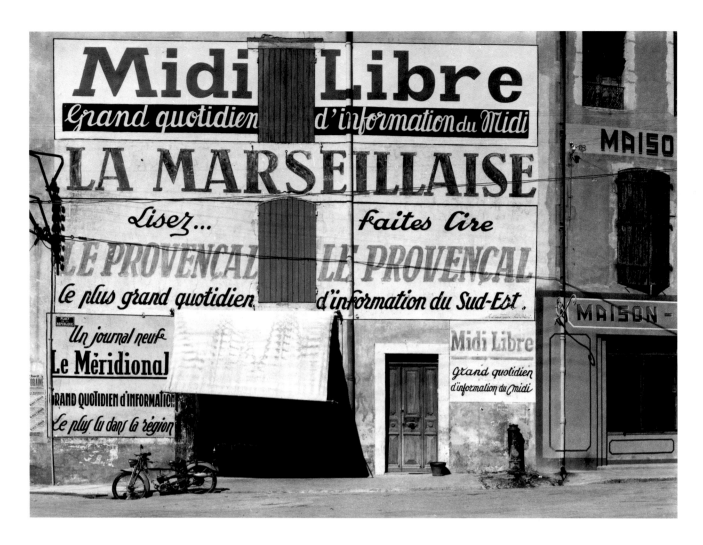

NIVOISE (DECEMBER)	PLUVOISE (JANUARY)	VENTOSE (FEBRUARY)	GERMINAL (MARCH)
1. *Peat*	1. *Daphne*	1. *Coltsfoot*	1. *Primula*
2. Coal	2. Moss	2. Dogwood	2. Plane tree
3. Bitumen	3. Ruscus	3. Red stock flower	3. Asparagus
4. Sulfur	4. Snowdrop	4. Privet	4. Tulip
5. *Dog*	5. *Bull*	5. *Billy goat*	5. *Chicken*
6. Lava	6. Viburnum	6. Asarum	6. White-beet
7. Planting soil	7. Tinder fungus	7. Buckthorn	7. Birch
8. Manure	8. Poplar	8. Violet	8. Jonquil
9. Saltpeter	9. Blight	9. Sallow	9. Alder
10. *Fléan*	10. *Granite*	10. *Axe*	10. *Spade*
11. Convoys	11. Hellebore	11. Narcissus	11. Periwinkle
12. Clay	12. Broccoli	12. Hornbeam	12. Elm
13. Slate	13. Laurel	13. Fumitory	13. Morel
14. Sandstone	14. Filbert tree	14. Hedge Mustard	14. Beech
15. *Rabbit*	15. *Lovage*	15. *Goat*	15. *Bee*
16. Flint	16. Boxtree	16. Spinach	16. Lettuce
17. Marl	17. Lichen	17. Leopard's Bane	17. Larch tree
18. Limestone	18. Yew	18. Scarlet Pimpernel	18. Hemlock
19. Marble	19. Lungwort	19. Chervil	19. Radish
20. *Horse-car*	20. *Pruning knife*	20. *Rope*	20. *Beehive*
21. Gypsum	21. Thlaspi	21. Mandrake	21. Judas tree
22. Salt	22. Thymelaea	22. Parsley	22. Romaine lettuce
23. Iron	23. Couchgrass	23. Cochlearia	23. Chestnut tree
24. Copper	24. Hogweed	24. Daisy	24. Rocket
25. *Cat*	25. *Ivy*	25. *Tuna*	25. *Pigeon*
26. Pewter	26. Wood	26. Dandelion	26. Lilac
27. Lead	27. Hazel tree	27. Wood anemone	27. Anemone
28. Zinc	28. Cyclamen	28. Maidenhair fern	28. Pansy
29. Mercury	29. Celandine	29. Ash tree	29. Blueberry
30. *Screen*	30. *Sleigh*	30. *Dibble*	30. *Grafting knife*

FLOREÁL (APRIL)

1. *Rose*
2. Oak
3. Fern
4. Hawthorn
5. *Nightingale*
6. Aquilegia
7. Lily of the valley
8. Mushroom
9. Hyacinth
10. *Rake*
11. Rhubarb
12. Sainfoin
13. Buttercup
14. Chamerisier
15. *Silk worm*
16. Comfrey
17. Bloodwort
18. Rock-alyssum
19. Orach
20. *Weeding hoe*
21. Sea lavender
22. Fritillary
23. Borage
24. Valerian
25. *Carp*
26. Euonymus
27. Civet
28. Bugloss
29. Mustard seed
30. *Trowel*

PRAIRIAL (MAY)

1. *Alfalfa*
2. Day-lily
3. Clover
4. Angelica
5. *Duck*
6. Melissa
7. Onion grass
8. Martagon lily
9. Wild thyme
10. *Scythe*
11. Dreadnought
12. Betony
13. Pine pitch
14. Acacia
15. *Quail*
16. Carnation
17. Elder tree
18. Poppy
19. Linden
20. *Hay fork*
21. Cornflower
22. Camomile
23. Honeysuckle
24. Yellow bedstraw
25. *Tench*
26. Jasmin
27. Verbena
28. Thyme
29. Peony
30. *Wagon*

MESSIDOR (JUNE)

1. *Rye*
2. Oats
3. Onion
4. Veronica
5. *Mule*
6. Rosemary
7. Cucumber
8. Shallot
9. Wormwood
10. *Sickle*
11. Coriander
12. Artichoke
13. Stock flower
14. Lavender
15. *Chamois*
16. Tobacco
17. Gooseberry
18. Vetch
19. Cherry
20. *Enclosure*
21. Mint
22. Cumin
23. Bush bean
24. Alkanet
25. *Guinea fowl*
26. Sage
27. Garlic
28. Vetch
29. Wheat
30. *Chalemie*

THERMIDOR (JULY)

1. *Spelt*
2. Aaron's rod
3. Melon
4. Cockle
5. *Ram*
6. Horsetail
7. Sagebrush
8. Safflower
9. Mulberry
10. *Watering can*
11. Panic grass
12. Purple loosestrife
13. Apricot
14. Basil
15. *Sheep*
16. Marsh mallow
17. Flax
18. Almond
19. Gentian
20. *Sluice*
21. Carlina
22. Caper bush
23. Lentil
24. Inula
25. *Otter*
26. Myrtle
27. Summer rape
28. Lupin
29. Cotton
30. *Mill*

FRUCTIDOR (AUGUST)

1. *Plum*
2. Millet
3. Lycoperdon
4. Winter barley
5. *Salmon*
6. Tuberose
7. Sugar melon
8. Dogbane
9. Liquorice
10. *Ladder*
11. Watermelon
12. Fennel
13. Barberry
14. Nut
15. *Trout*
16. Lemon
17. Teasel
18. Buckthorn
19. Marigold
20. *Hopper*
21. Wild rose
22. Hazelnut
23. Hops
24. Sorghum
25. *Crawfish*
26. Bitter orange
27. Golden rod
28. Corn
29. Chestnut
30. *Basket*

VENDEMIAIRE (SEPTEMBER)

1. *Grape*
2. Saffron
3. Chestnut
4. Colchicum
5. *Horse*
6. Garden balsam
7. Carrot
8. Amaranth
9. Parsnip
10. *Vat*
11. Potato
12. Everlasting flower
13. Pumpkin
14. Reseda
15. *Donkey*
16. Marvel of Peru
17. Gourd
18. Buckwheat
19. Sunflower
20. *Wine press*
21. Hemp
22. Peach
23. Turnip
24. Amaryllis
25. *Steer*
26. Eggplant
27. Pimento
28. Tomato
29. Barley
30. *Barrel*

BRUMAIRE (OCTOBER)

1. *Apple*
2. Celery
3. Pear
4. Beet
5. *Goose*
6. Heliotrope
7. Fig
8. Black salsify
9. Service-tree
10. *Plow*
11. Salsify
12. Water caltrop
13. Jerusalem artichoke
14. Endive
15. *Turkey*
16. Caraway
17. Watercress
18. Plumbago
19. Pomegranate
20. *Harrow*
21. Bacchante
22. Azarole
23. Madderwort
24. Orange
25. *Pheasant*
26. Pistachio
27. Rush
28. Quince
29. Sorb tree
30. *Roller*

FRIMAIRE (NOVEMBER)

1. *Rampion*
2. Kohl rabi
3. Chicory
4. Medlar fruit
5. *Pig*
6. Lamb's lettuce
7. Cauliflower
8. Honey
9. Juniper berry
10. *Pickaxe*
11. Wax
12. Horseradish
13. Cedar
14. Pine tree
15. *Roe-deer*
16. Gorse
17. Cyprus
18. Ivy
19. Savine
20. *Mattock*
21. Maple
22. Heather
23. Reed
24. Sorrel
25. *Cricket*
26. Pine seed
27. Cork aok
28. Truffle
29. Olive
30. *Shovel*

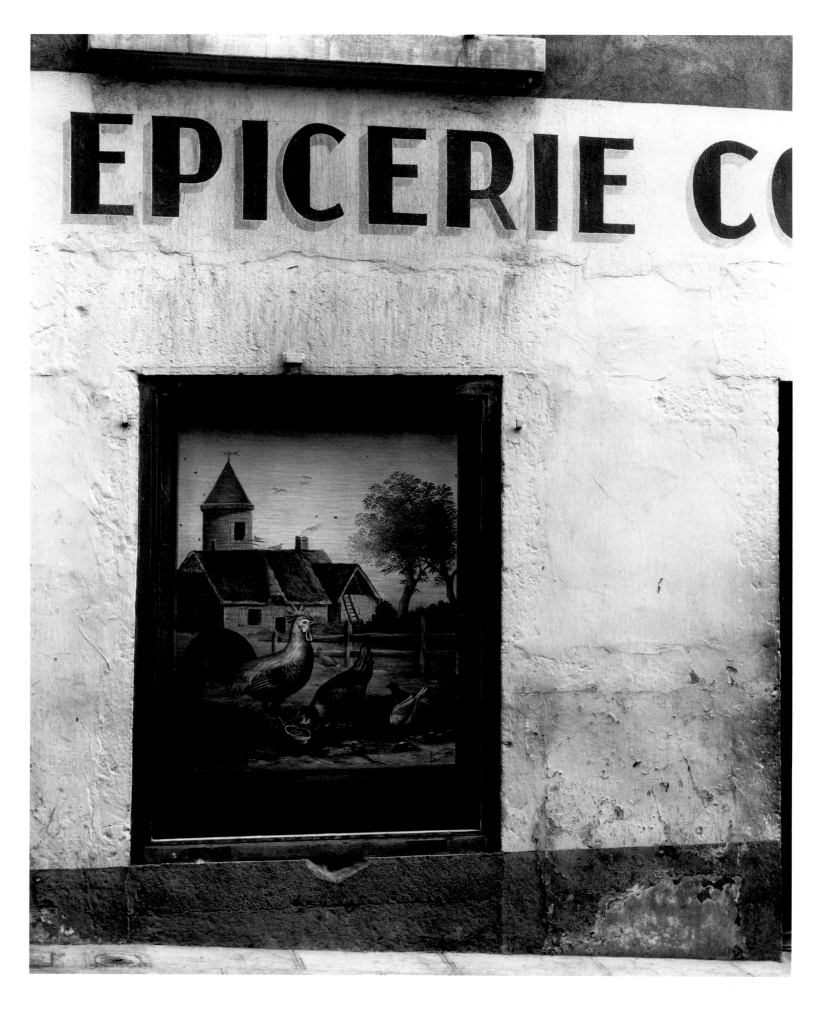

THE COCK

The French, because they like to postpone until later what they don't want to do today, decided to take the cock as their emblem. That way they hope they will not be late.

The cock is an alarmclock that runs fast. He sings in the dark that it is daytime. That isn't true. But they have ended up by establishing a cocksure connection between this rasping trumpet and the bright sunshine.

The cockerel, which they call Gaulish as the result of a pun, is a gallinaceous bird who always repeats the same thing. He sings from before dawn to dusk. He says: "France cock-a-dood-immortal." He has but a single cock-a-doodle string to his feathered rainbow.

The Gaulish cockerel is fond of his own opinion. After all, that is all he has. The cock feels that the chicken shouldn't sing before he does. When he is thwarted, the cock becomes as red as a rooster. When he is praised, the feather-legged cock is like a fighting cock. The cock never stays in one place, he jumps around from pillar to post, and when he is a weathervane cock, he jumps from north to south. The cock thinks he is the top dog of the universe. I prefer the lark to the cock, that raucous usurper with the fine name Chanticleer.

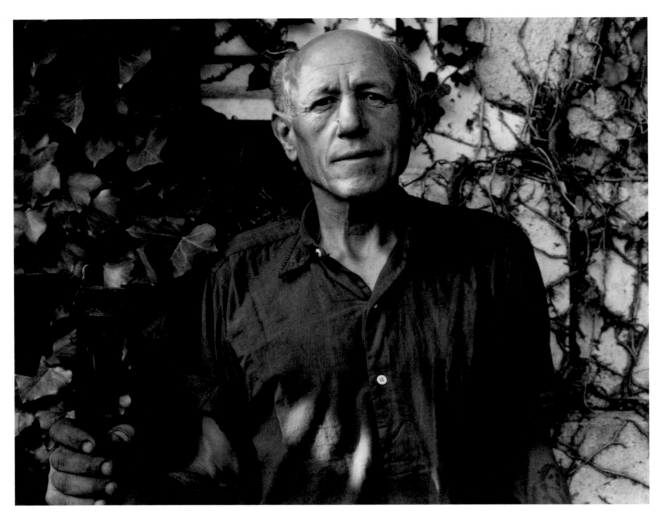

Les mêmes.

Nous n'avons pas besoin d'en dire davantage
gens du même pays parlent à demi-mot
Nos regards ont appris les mêmes paysages
Nous avons mêmes joies Nous avons mêmes maux

Nous avons cheminé dans les mêmes parages
goûté le même pain aimé le même vin
Nous nous sommes croisés dans les mêmes passages
Nous nous sommes cognés contre un même destin

The Same Ones

We need say no more about it, folks of the same land grasp with half a word
The same landscapes taught our eyes, we've got the same joys we've got the same hurts
We've wandered through the same places, tasted the same bread loved the same wine
We've run into one another at the same crossroads, we've come up against the same fate.

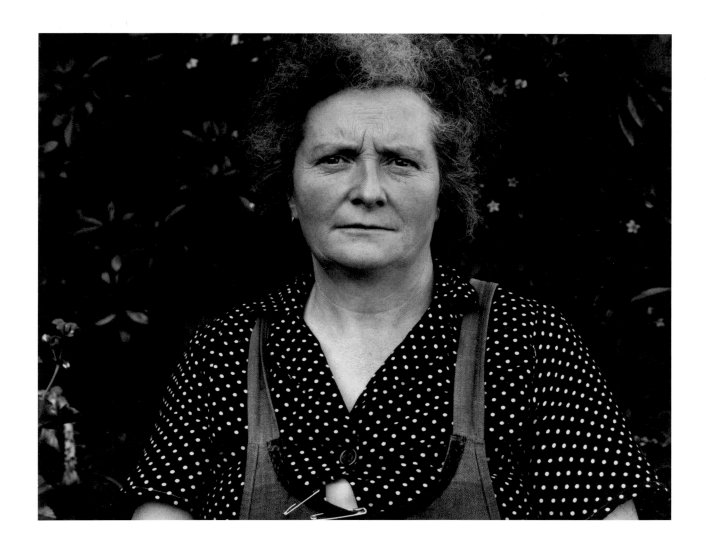

Nous nous sommes mouillés dans les mêmes orages
Nous nous sommes traînés dans les mêmes chemins
Nous nous sommes rêvés dans les mêmes images
Ah nous sommes bien faits pour nous donner la main !

Hommes de mon pays voisins de mon village
nous aurons même lit lorsque nous serons morts
Nous n'avons pas besoin d'en dire davantage
et la même clarté nous fait un même sort.

We've been soaked in the same storms, we've trudged down the same roads
We've imagined ourselves in the same images, ah we're well suited to hold each other's hand!
Men of my country neighbors of my village, we'll have the same bed when we are dead
We need say no more about it, that same clarity hands us a same lot.

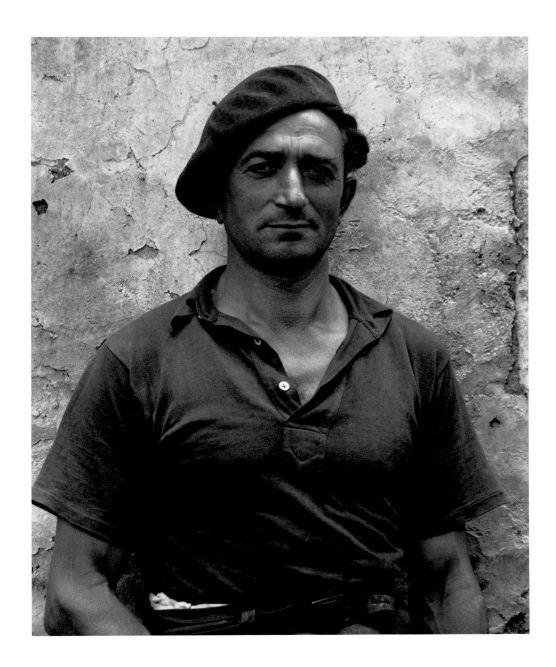

Nothing could be less natural than nature. What is natural is not that the grape ripens, swells up, bathes in the sun and is cut to be made into dessert or wine. What is natural is that the vine, before being taken, should be stifled by weeds and burnt by drought, that the shoots and the leaves should be poisoned by phylloxera or eaten up by chlorosis, that the vegetation and the fruit should be strangled by frost, chewed up by mildew and oidium, that the hail should shoot them down or the humidity make them moldy.

A bunch of grapes is not so much a work of nature, as it is a work of art. And this still life is not as still as one might think. Man lives there, on every centimeter of leaf, of pulp, of matter. It is he who has pruned the vine stock, covered the green leaf with blue copper sulfate, dusted each bunch with sulfur and copper-colored lime, snipped off the excess growth.

You look at a grape. Remember to look for a man in there, and for his patience, and his ingenuity and his suffering, and his happiness. France is the country where inhuman nature no longer exists.

France, fiancée promise.

X

Si dorment dans le vent des prairies de septembre
plus confondus tous deux que le nuage au jour
les amants le sommeil en mélangeant leurs membres
fait monter dans le sang du sol un long bruit sourd

Hommes d'après nous deux vivants d'après nos morts
vous piétinez au fond du silence et du noir
j'entends venir à moi du très loin de l'aurore
un monde où la bonté rit dans tous les miroirs

un monde qui fera les quatre volontés de l'homme

Et si vous demandez tout bas n'osant encore y croire
qui sont ces étrangers ils ignorent la haine
et pour qui cette fête chaque jour recommencée
pour qui cette clarté des lampes et qui donc a
donné aux jours cette simplicité de jour tout frais levé
et pourquoi ces rires cette musique cette gaîté du vent
enfin enfin semblable à cette fraîcheur

France, the betrothed

Asleep here in the green of the meadows of September, both more closely together than the cloud is with day
the lovers lie as sleep merges their limbs and makes a long muffled sound rise from the blood of the soil

You people coming behind us, who live on after our deaths, you're walking in the depths of silence and the dark
I hear a world coming toward me from far off in the dawn, a world in which goodness laughs reflected in all mirrors

a world that will give in to mankind's every whim

And if you ask in a whisper as you dare not believe it yet, who are those strangers there they do not know of hatred
and for whom this celebration begun every new day, for whom this brightness of the lights and who then has
given the days this simplicity of a new day freshly risen, and why this laughter this music this gaiety of the wind
at last at last resembling the first glow.

si longtemps imaginée si longtemps poursuivie
et si vous demandez qui sont ces hommes
à visage d'hommes vivants ces hommes habillés
de joie simple et de confiance claire
le vent vous répondra

Ils sont vous-même vous enfin très ressemblant
au visage parfait qui s'ignorait en vous
Ils sont votre espérance qui parlait au futur
et qui dit au présent l'homme ami de lui-même.

Ma présente ma promise
je t'aime pour hier
pour aujourd'hui

et pour demain.

We have so long imagined and so long pursued, and if you ask who these men are
with faces of people alive these men dressed in simple joy and bright confidence
it is the wind who will answer you

They are yourselves at least much like you, with the flawless face that did not know itself in you
They are your hope that used to speak in future tense, and now says in the present that man has befriended himself.

My present one my promised one
I love you for yesterday
and for today
and for tomorrow.

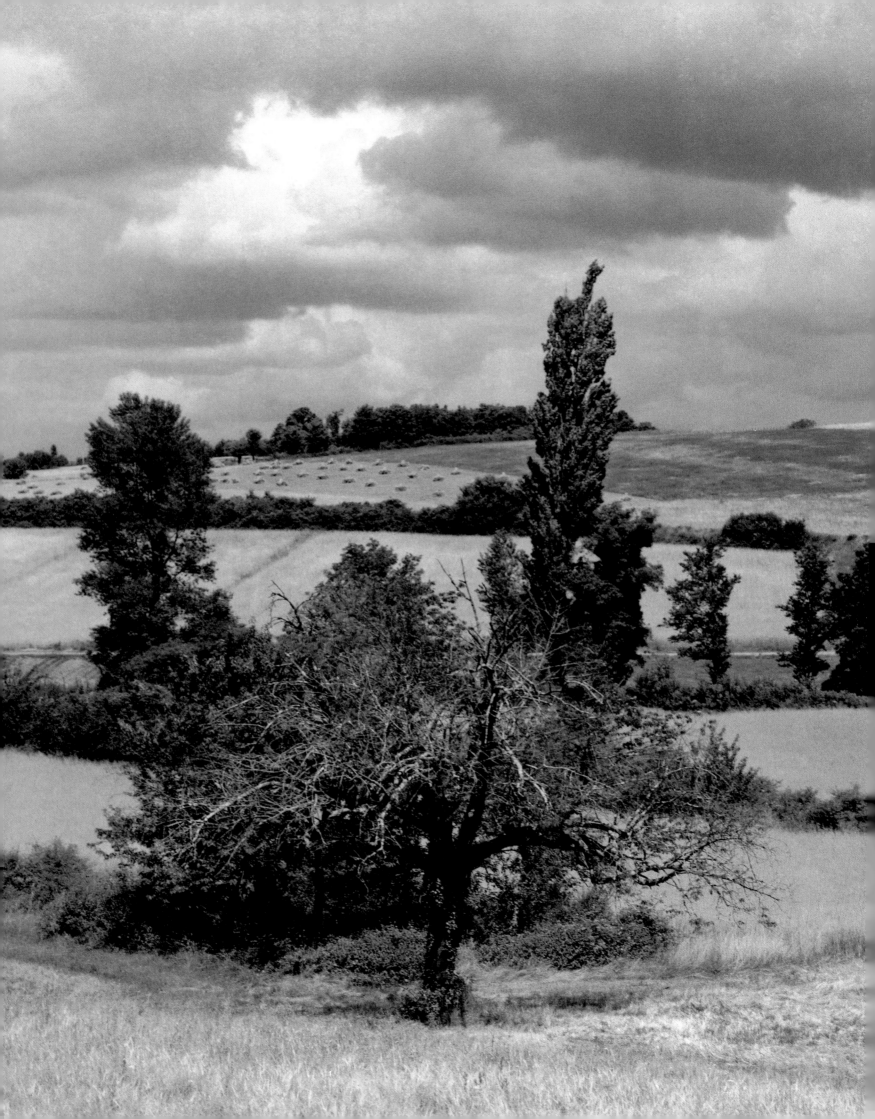

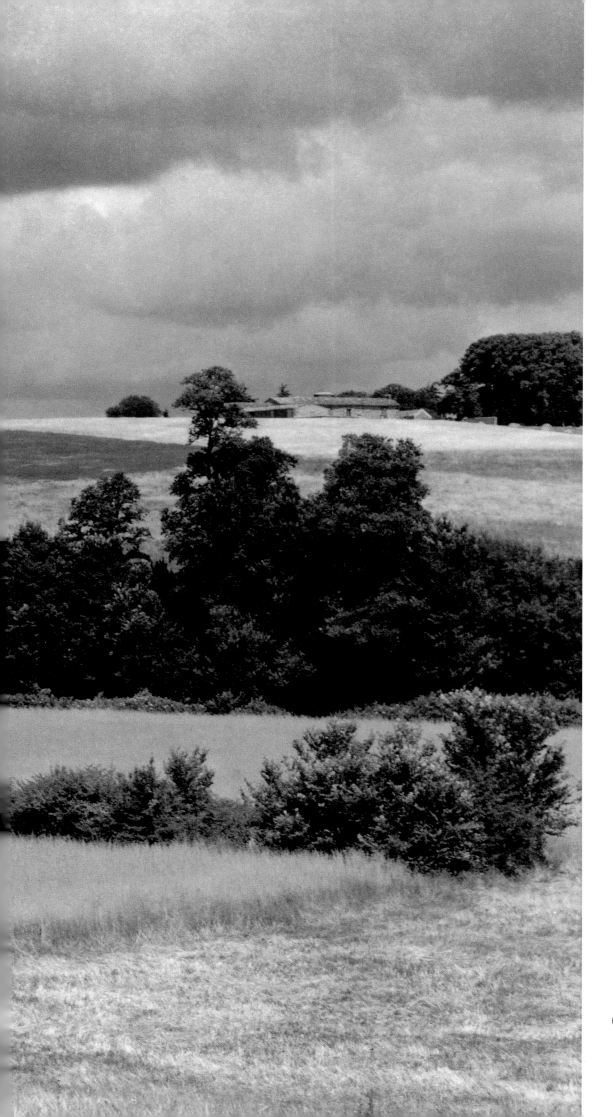

Claude Paul
Roy Strand

LIST OF ESSAYS

LIST OF ILLUSTRATIONS

UNLESS OTHERWISE NOTED, ALL PHOTOGRAPHS WERE TAKEN IN FRANCE BETWEEN 1950-51.

Library of Congress
Catalog Card Number: 00-111-698
Hardcover ISBN: 0-89381-874-7

Design by Michelle Dunn Marsh based on the original layout by Claude Roy and Paul Strand.

Separations by Thomas Palmer,
Newport, Rhode Island
Printed and bound by Mariogros Industrie
Grafiche SpA, Turin, Italy

The Staff at Aperture for *La France de Profil*:
Michael E. Hoffman, Executive Director
Hiuwai Chu, Associate Editor
Stevan A. Baron, V.P., Production
Lisa A. Farmer, Production Director
Marjolijn DeJager, Translator
Bryonie Wise, Editorial Work-Scholar
Heather McGinn, Production Work-Scholar

Aperture Foundation publishes a periodical, books, and portfolios of fine photography and presents world-class exhibitions to communicate with serious photographers and creative people everywhere. A complete catalog is available upon request. *Aperture Customer Service:* 20 East 23rd Street, New York, New York 10010. Phone: (212) 598-4205. Fax: (212) 598-4015. Toll-free: (800) 929-2323. E-mail: customerservice@aperture.org

Aperture Foundation, including Book Center and Burden Gallery: 20 East 23rd Street, New York, New York 10010. Phone: (212) 505-5555, ext. 300. Fax: (212) 979-7759. E-mail: info@aperture.org Visit Aperture's website: www.aperture.org

Aperture Foundation books are distributed internationally through:
CANADA: General/Irwin Publishing Co., Ltd., 325 Humber College Blvd., Etobicoke, Ontario, M9W 7C3. Fax: (416) 213-1917.

UNITED KINGDOM, SCANDINAVIA, AND CONTINENTAL EUROPE: Aperture c/o Robert Hale, Ltd., Clerkenwell House, 45-47 Clerkenwell Green, London, United Kingdom, EC1R OHT. Fax: (44) 171-490-4958.

NETHERLANDS, BELGIUM, LUXEMBURG: Nilsson & Lamm, BV, Pampuslaan 212-214, P.O. Box 195, 1382 JS Weesp, Netherlands. Fax: (31) 29-441-5054.

AUSTRALIA: Tower Books Pty. Ltd., Unit 9/19 Rodborough Road, Frenchs Forest, Sydney, New South Wales, Australia. Fax: (61) 2-9975-5599.

NEW ZEALAND: Southern Publishers Group, 22 Burleigh Street, Grafton, Auckland, New Zealand. Fax: (64) 9-309-6170.

INDIA: TBI Publishers, 46 Housing Project, South Extension Part-I, New Delhi 110049, India. Fax: (91) 11-461-0576.

For international magazine subscription orders to the periodical *Aperture*, contact Aperture International Subscription Service, P.O. Box 14, Harold Hill, Romford, RM3 8EQ, United Kingdom. One year: $50.00. Price subject to change. Fax: (44) 1-708-372-046.

To subscribe to the periodical *Aperture* in the U.S.A. write Aperture, P.O. Box 3000, Denville, New Jersey 07834. Toll-free: (800) 783-4903. One year: $40.00. Two years: $66.00.

SECOND EDITION
10 9 8 7 6 5 4 3 2 1